# RICHARD BELL

# RICHARD BELL

## UZ VS. THEM

**Maura Reilly with Richard Bell and Djon Mundine**
**With a Foreword by Eleanor Heartney**

American Federation of Arts in association with D Giles Limited, London

This catalogue is published in conjunction with *Richard Bell: Uz vs. Them*, an exhibition organized by the American Federation of Arts and supported by the Queensland Government, Australia, through Trade and Investment Queensland's Queensland Indigenous Arts Marketing and Export Agency (Q.I.A.M.E.A.). Additional support has come from the Australian government through the Australia Council for the Arts and the Embassy of Australia, Washington, D.C.

The American Federation of Arts is a nonprofit institution that organizes art exhibitions for presentation in museums around the world, publishes exhibition catalogues, and develops education programs.

Guest Curator: Maura Reilly

For the American Federation of Arts:
Director of Publications: Michaelyn Mitchell

For D Giles Limited:
Copyedited and proofread by Melissa Larner
Designed by Alfonso Iacurci

Produced by GILES, an imprint of D Giles Limited, London
Printed and bound in China

Photo credits: Most photographs of works or art reproduced in this volume have been provided by the owners or custodians of the works and are reproduced with their permission. The following additional photo credit applies to the catalogue numbers indicated: Ray Enders, cat. nos. 3, 4, 5, 6, 8, 9, 12, 14, 15, 19, 22, 25.

All measurements are in inches; height precedes width.

**Front cover:**
*Scratch an Aussie #4* (detail) (cat. no. 21)

**Back cover:**
Detail of *Wewereherefirst* (cat. no. 17)

**Frontispiece:**
From *Psalm Singing Suite* (cat. no. 19)

First published in 2011 by the American Federation of Arts in association with D Giles Limited, London. All rights reserved. No part of the contents of this book may be reproduced, stored in a retrievable system, or transmitted in any form or by any means without the written permission of the American Federation of Arts and D Giles Limited.

10 9 8 7 6 5 4 3 2 1

American Federation of Arts
305 East 47th Street, 10th Floor
New York, NY 10017
www.afaweb.org

D. Giles Limited
4 Crescent Stables
139 Upper Richmond Road
London SW15 2TN
England
www.gilesltd.com

Hardcover ISBN: 978-1-904832-95-9
Softcover ISBN: 978-1-885444-40-0

**Exhibition Itinerary**

Tufts University Art Gallery
Medford, Massachusetts
September 14–November 20, 2011

University of Kentucky Art Museum
Lexington, Kentucky
February 12–May 6, 2012

Victoria H. Myhren Gallery
University of Denver
Denver, Colorado
September 13–December 9, 2012

Indiana University Art Museum
Bloomington, Indiana
March 1–May 5, 2013

**Library of Congress Cataloging-in-Publication Data**

Reilly, Maura.
  Richard Bell : uz vs. them / Maura Reilly with Richard Bell and Djon Mundine ; with a foreword by Eleanor Heartney. -- 1st ed.
     p. cm.
  Published in conjunction with a traveling exhibition organized by the American Federation of Arts which will be displayed at the Tufts University Art Gallery and three other institutions between Sept. 14, 2011 and May 2013.
  Includes bibliographical references and index.
  ISBN 978-1-904832-95-9 (hardcover) -- ISBN 978-1-885444-40-0 (softcover)
  1. Bell, Richard, 1953---Themes, motives--Exhibitions. 2. Art and society--Australia--Exhibitions. I. Bell, Richard, 1953- II. Mundine, Djon. III. American Federation of Arts. IV. Tufts University. Art Gallery. V. Title. VI. Title: Uz vs. them.
  N7405.B45R45 2011
  759.994--dc22

                              2010050766

# CONTENTS

# FOREWORD

Eleanor Heartney

## Aboriginal Art—It's a White Thing.
## Australian Art—It's an Aboriginal Thing.

Richard Bell, "Bell's Theorem"

Provocation and paradox are the stuff of Richard Bell's art—qualities that allow him to infuriate the Australian art establishment while forcing it to acknowledge and even honor him. Through nimble role-playing, unsettling humor, and the refusal of established categories, he attacks the mythologies of cultural authenticity, identity, and race as they have coalesced around the notion of Aboriginal art and aboriginality. With the two phrases above, which appear both in Bell's paintings and his writings, he concisely sums up the peculiarities of art and identity in Australia. However, the tensions that he articulates spill beyond Australia's borders, making his analysis pertinent to some of the most vexing issues haunting the contemporary art world.

One way to get at the significance of Bell's contribution is to examine a set of questions that his work implicitly raises. Question number one: is he or isn't he an Aboriginal artist? From one perspective the answer is unequivocally yes—Bell is an Aboriginal individual who makes art. However, in Australia, this may not be enough to establish his credentials. The burgeoning market for paintings and sculptures created in "traditional" Aboriginal styles has made questions of authenticity key to the whole enterprise. Collectors are looking for vestiges of Aboriginal spirituality and the romance of "dreamtime" as explained to them by non-Aboriginal anthropologists. They are emphatically

not looking for the scrappy, conceptually based, provocative paintings and videos of an "urban Aboriginal" who refuses to stay put in what ethnographer James Clifford calls the "ethnographic present." By this, Clifford refers to a state of unchanging tradition that freezes a "primitive" culture in an ahistorical past untouched by the flurry of the modern world.

But this preference for stasis begs the question, why is a sand painting pattern that has been diluted and transferred to canvas to make it saleable a more authentic commodity than a work by an artist of Aboriginal descent living in, working in, and reacting to the contemporary world? Why has reference to its traditional Aboriginal culture become one of the defining qualities of Australia's identity in the international cultural world? Does this not confirm Bell's contention that Australian art is an Aboriginal thing?

Question number two: is Bell Aboriginal or not? Here the question again is not so much a matter of pedigree as of politics. Identity politics as it has emerged from the academy and the cultural world was originally taken up as a corrective to institutionalized racism, sexism, and homophobia. However, it has too often devolved into a self-limiting embrace of "otherness" and victimhood that keeps its subjects marginalized. As a result, a number of progressive thinkers have begun to question

the whole notion of race and identity. In a forum organized in 1985 for the publication *Critical Inquiry*, Henry Louis Gates, Jr., chair of Harvard's Department of African and African American Studies, posed the question "Does race exist?" Somewhat surprisingly, considering how frequently the term is bandied about in common parlance, he argued that it does not. Gates pointed out that there is no basis in either science or biology for absolute distinctions on the basis of race. Instead, he suggested, "racial" categories are arbitrarily applied to distinguish groups that may have wildly different cultures, belief systems, and economic interests. Once institutionalized, this categorization then becomes a construct—and the basis for differential treatment. From this perspective, then, Bell's Aboriginality is not something innate but something forced upon him by history and social convention. In other words, Aboriginality is a white thing.

Question number three: is Bell an artist? In a much-quoted sound bite, he has remarked, "The thing I do best is show off." Prior to his art life, which began when he was thirty-four, he was an activist for Indigenous rights. In many ways, his artworks are simply an extension of that battle. To this end, Bell has mastered the role of the trickster, wrapping up his assertions about the miserable treatment that Australia's Indigenous peoples have received at the hands of the European colonizers in an antic humor that makes the medicine go down a bit more palatably.

But is it art? The formalists and connoisseurs may disagree, but Bell is firmly in the camp of avant-gardist provocateurs like Marcel Duchamp, John Heartfield, and other practitioners of Dadism and Situationism for whom art offered an opportunity to provoke thought and undermine oppressive systems of social organization. Coming closer to the present, one might put Bell in the company of activist artists like Adrian Piper, Guillermo Gomez-Peña, Jimmie Durham, and James Luna, who play the cards of confrontation, absurdism, role reversal, and humor in order to unsettle art audiences' cherished assumptions about their supposed "otherness." So it all depends on your definition of art and how it should function in society. To offer up another pithy quote by Bell: "Art gives an independent voice . . . In European terms it goes back to the days of the roving minstrels,

puppeteers, and court jesters. We are still performing those roles." From this perspective, art is a subversion thing, a function that Bell is well equipped to perform.

Through shape-shifting, upending of hierarchies, and challenges to cherished assumptions, the art of Richard Bell works its way into the heart of contemporary pathologies. He wields his art like a scalpel, using it to get under the skin of contemporary Australian culture in order to scrape away the accumulated contagions of history. In the process, he provides a remarkably effective model for thinking about larger issues as well. He reminds us that none of us can escape the paradoxes of identity and authenticity in a post-colonial world.

# CURATOR'S PREFACE

Maura Reilly

In school I was taught the names
Columbus, Cortez, and Pizarro and
A dozen other filthy murderers.
A bloodline all the way to General Miles,
Daniel Boone and General Eisenhower.
. . .
In school I learned of heroic discoveries
Made by liars and crooks. The courage
Of millions of sweet and true people
Was not commemorated.

Jimmy Durham, excerpt from
"Columbus Day," 1983

Growing up in the United States, I never understood why the second Monday in October was called Columbus Day in recognition of Christopher Columbus's "discovery" of America in 1492. How can you discover something that's already occupied, I asked my elders? And, if there was to be a day in observance of this so-called discovery, then why was there not a holiday commemorating the Native Americans who had first occupied the land for hundreds of thousands of years? When is Native American Day, I wondered? And why, I asked, are Indians portrayed in movies as savage, evil, and violent when they were only protecting what was theirs in the first place? "Don't be cheeky," I was sternly warned by parents and teachers.

Thus it was that I learned about racism, hypocrisy, denial, white guilt, and historical amnesia and about how history itself is made up of many his-stories, subjective narratives written by (mostly) white men. I realized, too, that the colonizing white settlers would never admit to the near-genocide and dispossession of innumerable Indigenous peoples and that they would forever deem them uncivilized "savages" in order to justify their horrendous behavior.

Australia has a similar his-story. A white man named Captain Cook is said to have "discovered" the continent in 1770. The British crown justified the occupation using the doctrine of *terra nullius*—meaning "land belonging to no one." Another lie. Indigenous populations had lived on the land for millennia but were not recognized as the rightful owners. In the interest of the Commonwealth, then, from the late eighteenth century onwards, these people were killed, robbed of their lands, relocated onto missions; their children were stolen, and they were forced to work for far lower wages than the white settlers. So oppressed were these people that they were denied the right to vote until 1962 and were not counted in the national census until 1967, considered instead as part of the "native" fauna and flora; in other words, they were not considered human beings. The backdrop to this discriminatory history is the Australian government's White Australia Policy, which was only repealed in 1973 by Prime Minister Gough Whitlam.

There is no Australian artist who more directly addresses this checkered history than Richard Bell. A self-taught artist whose own biography speaks volumes about the continued oppression of Indigenous Australians today, Bell has been producing work since the late 1980s that investigates the plight of his people.

I first met Richard at a Tony Albert art opening in 2007—or perhaps I should say that I met "Richie," his hilarious alter ego. I was immediately drawn to his intelligence and fierce wit. Afterward, I was eager to see his work. I was hugely impressed. Bell invokes the formal aesthetics of Aboriginal desert paintings (with their dot matrixes and expressionist drips) while usurping mainstream Pop art styles à la Roy Lichtenstein, all combined with pithy political statements that cry out for action against the racist Australian culture within which he finds himself.

Among Bell's corollaries are Jimmie Durham, James Luna, Emory Douglas, Daniel Martinez, Kara Walker, Carrie Mae Weems, Fiona Foley, Newall Harry, Gordon Bennett, and Gordon Hookey, all of whom have taken "identity politics" as their subject, appropriating popular imagery against itself to subvert its often inherently derogatory message—be it genocide, slavery, dispossession, land rights, the Stolen Generations, police brutality, extinction of languages, and/or basic human rights. Like those of his American and Indigenous Australian comrades, Bell's ideas about the subjugation of the underprivileged and oppressed are universal.

*Richard Bell: Uz vs. Them* is the first traveling exhibition in the United States dedicated to Bell's work. The subtitle of the exhibition, which takes its cue from a 2006 Bell video of the same name, similarly aims to problematize destructive binaries vis-à-vis a linguistic shifter. After all, who is "uz" and who is "them"? And must this forever-dueling binary always be maintained?

# ACKNOWLEDGMENTS

The resonant, powerful, and provocative work of Australian artist Richard Bell has gained him an increasingly international presence, and the AFA is delighted to present his broad-ranging talents to an audience in the United States with this first traveling exhibition of his work. We are very grateful to Bell for his cooperation throughout the development of this project, as well as for the essay he has contributed to the book. We wish also to acknowledge the work of our Guest Curator, Maura Reilly, formerly AFA's Senior Curator of Exhibitions. Deeply committed to this artist for some time, she brings keen insight to the presentation of his work. Our thanks also go to Djon Mundine for his essay; Eleanor Heartney for her foreword; and Amy Spencer, former AFA intern, for preparing the timeline and bibliography and for research for the entries. We are also grateful to Josh Milani of the Milani Gallery in Brisbane, Australia, and the staff at Location One in New York for their assistance.

We very much appreciate the generosity of the lenders who allowed us to borrow their artworks and whose participation made this exhibition possible.

We wish to extend our thanks to the Queensland Government, Australia, for the funding we have received from them through Trade and Investment Queensland's Queensland Indigenous Arts Marketing and Export Agency (QIAMEA). We also wish to acknowledge the additional support we have received from the Australian government through the Australia Council for the Arts and the Embassy of Australia in Washington, D.C.

The staff of the AFA deserve recognition for their wonderful work on behalf of the exhibition and publication. I wish to thank Suzann Dunaway, Grant Writer, for her work on the funding front; Anna Hayes, Manager of Exhibitions, for her critical oversight of the project; Michaelyn Mitchell, Director of Publications and Communications, for coordinating the production of this handsome catalogue; Lauren Palmor, Publications/Communications Assistant for her assistance with the publication and the publicity for the exhibition; and Dottie Teraberry, Registrar, for preparing and touring the exhibition. Thanks also go to Amy Brandt, formerly AFA Assistant Curator of Exhibitions, for her work on many aspects of the exhibition's development, in particular the organization of the national tour, and Dan Giles at D Giles Limited for partnering with the AFA on the publication of this book.

Finally, we recognize the wonderful university galleries participating in the tour of this important exhibition—the Tufts University Art Gallery; the University of Kentucky Art Museum; the Victoria H. Myhren Gallery at the University of Denver; and the Indiana University Art Museum. It has been a great pleasure to work with them, and we thank them for being such professional and enthusiastic partners.

Pauline Willis
*Chief Operating Officer*
*American Federation of Arts*

For their support of this project, I would like to thank Claire Montgomery, George King, Michaelyn Mitchell, Amy Spencer (for her extraordinary research), Amy Brandt (for her dogged determination and close friendship), and especially Tracey Moffatt, whose insights and continual support have been invaluable. Kon Gouriotis from the Australia Council for the Arts and Helena Gulash and Avril Quaill from the Queensland Indigenous Arts Marketing and Export Agency (QIAMEA) are to be thanked as well; without their financial support, this project would not have been possible. Most importantly, I would like to thank Richard Bell and Josh Milani, his dealer, for their good humor and overall generosity of spirit.

Maura Reilly

# WE WERE HERE FIRST: AN INTERVIEW WITH RICHARD BELL

Maura Reilly

**Maura Reilly:** In order to contexualize your work for American audiences, can you sketch the history of colonization in Australia and its effects on the Indigenous population?

**Richard Bell:** Australia was the last continent to be colonized by a European nation. Captain James Cook from England is credited with having "discovered" Australia. It's no mean feat to travel half way around the world by wind power and force of will in 1770. But, really, how could they have "discovered" something that wasn't "lost" in the first place? Notwithstanding that not insignificant and often ignored fact, a civilian expedition would follow in 1788. Just five years after the end of the American War of Independence, a fledgling colony was established in Botany Bay. At the time, Great Britain needed somewhere to repatriate its unruly citizens, somewhere to dump its hugely criminalized population, generally the Irish.

The colonials landed in the new English colony curiously named New South Wales with the express instruction to "establish intercourse with the natives." However, it wasn't long before the colonialists deviated brutally from the script written for them from faraway England. Inevitably, things went pear-shaped for the people who just happened to be there first, the Aborigines.

**MR:** "Pear-shaped" is too nice of a word for what happened. The European settlers essentially slaughtered the Indigenous population upon arrival. They stole their lands, which the British crown justified by declaring (falsely) that Australia was a *terra nullius* [meaning "land belonging to no one"]. Then, from the late eighteenth century until as recently as the 1970s, the government "stole" Aboriginal children from their families, placing them into "homes" or foster care, in an effort to wipe out future Indigenous populations. And throughout the twentieth century, a succession of legislative acts and administrative decisions stripped away any semblance of justice for the majority of Aboriginal people.

**RB:** Yes, and to some people it appears that the Australian government, and by extension the Australian people, have embarked upon a path that can only bring about the extinction of the Aboriginal people and Aboriginal culture. Recent census figures report that Aboriginal people make up only 2½ percent of the total Australian population.

**MR:** Since this history of colonization and your early biography has so enormously affected your politics, what can you tell me about your childhood?

**RB:** I come from the Kooma, Kamilaroi, Jiman, Goreng Goreng peoples. I was born in 1953 in Charleville in southwestern Queensland, in the base hospital there. I lived my first two years in a tent on the *yumba*, waiting for the white people to throw away enough corrugated iron sheets for our family—me, my brother, and my mum—to build a tin shack and move up in life—from a tent to a tin shack.

**MR:** And your father?

**RB:** He was out droving or cane-cutting. The men all did some sort of seasonal work because that was basically the only work available for Aboriginal people then. We survived by living off the land because in the 1950s our people weren't allowed into the shops in town. We might be able to get some food, like some fruit and veggies from the Chinese garden, but basically, we had to go out and hunt the native animals and the not-so-native animals as well. I never had a new pair of shoes the whole time I was growing up. Or, if I did have them, I'd wear them out and have to stuff them with bits of leather or even cardboard. And there were always burrs, like bullheads or catheads, and cactus around you, you know? Damn, you needed shoes, especially school shoes, man.

In 1959, my brother Marshall and I moved with our mother, Sarah Bell, to the Retta Dixon Home in Darwin, where she got a job. It was a place where the state brought half-caste and "stolen" Aboriginal children in the Northern Territory. There was very little fun there. There was a dormitory with all these Aboriginal boys and young men, sleeping in row upon row of beds, coir mattresses, and pillows [see illustration on facing page of the girls' dormitory, described by Bell as much nicer than the boys' dormitory]. It was horrific. Me and my brother—I was six at the time and he was three—had to sleep

there in that dormitory, away from our mother for the first time. That was pretty traumatic.

**MR:** I can't even begin to imagine how difficult that must have been. What about your mum though—what was her job at the Dixon Home?

**RB:** My mother was employed by Retta Dixon as a House Parent at the new home. Basically, she was employed to help save our souls. As for the children there and our well-being and needs and aspirations, I don't remember that having any significance at all. Everything was very paternalistic. They always knew what was best for us. My mother did her best to make things easier for us though. She'd earn extra money by selling paintings or making and decorating wedding cakes. We were also taken on hunting trips by some of the local blackfellas outside Retta Dixon.

**MR:** Isn't that how you first learned to paint—by helping your mother decorate cakes?

**RB:** Yeah, I guess so. I used to help her with the decorating. She was being commissioned to make wedding cakes, baskets, crocheted and knitted items from as long as I can remember. I believe my maternal grandfather taught her to paint and cook. I don't know who taught her to carve, knit, and crochet. She was good at all that stuff. Real good. I often speculate as to what she could have done with her life given the opportunities that I've been given. I believe she would have made a successful career in art for herself. I guess it's natural that I inherited some of her talent.

**MR:** How long did you live there, at the Retta Dixon Home?

**RB:** We lived there until 1965. I was turning twelve. Then we moved from Darwin to Rockhampton, then to Charleville in 1966. After that, we returned to Mitchell, where we lived in a tin shack on an Aboriginal Reserve across the river from town. The council bulldozed our shack nine months after the 1967 referendum, which had formalized our existence in legal terms. That is, for the first time we were not counted in the census as flora and fauna.

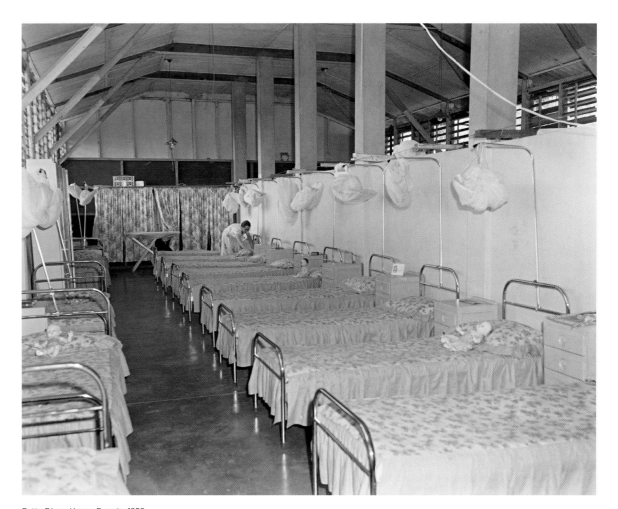

Retta Dixon Home, Darwin, 1958.
National Archives of Australia
(NAA: A1200, L28772)

After my mother died in 1970, when I was seventeen, my brother and I were sent to live with a family we knew in Dalby. That was the first time in my life that I remember being treated like a human being by the majority of the white people living in that town. That was a great help to me because I didn't know what I was going to do with my life. I couldn't understand how we Aborigines could be the descendants of the owners of the lands that we were living on but still be so impoverished and oppressed. I started learning about black consciousness and the fact that we Aborigines have rights that are inalienable.

After I finished high school in Dalby, I spent the next decade getting laid and drinking beer. Those were the years I became politicized and involved in the Aboriginal rights movement. I was just another foot soldier playing a supportive role—among other things, participating in numerous demonstrations to protest discrimination against Aboriginal people. Living in Brisbane, Sydney, Moree, and Kempsey, I got to know hundreds of political activists, artists, poets, and writers—like Paul Coe, "Sugar" Ray Robinson, Gary Foley, Kevin Smith, John Newfong, Naomi Meyers, Ray "Big Bird" Swan, Lyall Munro Jr., Isabelle Coe, Jenny Munro, Bronwyn Penrith, Mick Miller, Kevin Gilbert, Bob Mazza, Greg "Jup" Davis, Chicka Dixon, Charlie Perkins, Dave Fernando, Kenny Weldon, and Lee Combo. I'm going to get in trouble here for all the names I left out, so a big sorry to you all! [Laughs]

In the early 1980s, I worked for the New South Wales Aboriginal Legal Service in Sydney. This period marked the steepest learning curve of my life. I met blackfellas from all over Australia, from all walks of life, in a myriad of different circumstances—but always discussing the same issues and searching for solutions. Some events that stand out are the protests against the 1982 Commonwealth Games in Brisbane and the protests against the New South Wales Aboriginal Land Rights and Revocation of Lands Act, 1983. For the latter, we protested that it was unfair, unethical, and immoral to retrospectively validate the previously illegal revocations of Aboriginal lands in New South Wales. We were demanding that they withdraw that aspect of the legislation because it disqualified Aboriginal people from being compensated for the loss of those lands.

**MR:** At what point did you decide to merge this activism into art production?

**RB:** I didn't actually get into art until I was thirty-four, in 1987. I'd been working with, among, and for Aboriginal people for more than ten years, mostly in welfare-type situations. I needed a change, and joining my brother Marshall in making and marketing Aboriginal souvenirs seemed like an attractive option. We had a business that supplied boomerangs and other tourist items to the Queensland Aboriginal Creations, a government-owned enterprise. It was a small retail outlet in south Brisbane called Wiumulli Gallery. This was where I learned about commerce and the commodification of Aboriginal culture. Surprisingly, lots of people liked the tourist art we produced. I called them my "pretty pictures."

One day, I was drawing these pretty tourist pictures when this guy came in and said, "Why don't you get into fine art?" I said, "What are you talking about, motherfucker? Look at these *fine* lines here." [Laughs] And he laughed, of course, but said, "No, I mean high art. Look, you can reach a bigger and a more influential audience through art than you can marching up and down the street." "Oh," I said. "No. If I did that, I'd tell these white folks exactly what I think of them." And he said, "Just do it." So I thought about that; I rang him a couple of days later, and he took me around to galleries, museums, art colleges, and artists' studios. I had a good look at the art world. What I saw was that there was nobody doing what I wanted to do, which was to make art about the hopes, dreams, and aspirations of Aboriginal people. I mean, there were a lot of Aboriginal people talking about issues, but they were being subtle about it. I wanted to do something really direct. So when I started making art, it got collected straight away because it filled a gap.

**MR:** Was your first solo exhibition held at Wiumulli, the tourist art gallery?

**RB:** No. My first solo show was held in the dressing room of the Spring Hill Baths in 1989. *This Black and White Thing* was the title of the exhibition, which was kind of ironic considering that

Michael Jackson released his latest album, *Black and White*, that same night. The works from this first show were small and text-based, often with collaged reproductions of Aboriginal people. They were similar in style to my painting *Crisis: What To Do about This Black and White Thing*, made in 1991 [see illustration].

**MR:** Was this first exhibition well received by the critics?

**RB:** Yeah, it was, but to be honest, I thought art was bullshit, a con job. However, I did get to meet lots of great people over the next five or six years. Some were artists, curators, critics, art dealers, and art collectors, and some were not involved in art. But they were all art lovers. I was fortunate enough to witness the "magic" of art. This led me to have such a high appreciation for art and all its participants that I've been reluctant to call myself an artist ever since. When I say that I don't consider myself an artist, I'm being honest. I see myself primarily as an activist rather than an artist.

**MR:** And your weapon of choice as an activist is . . . ?

**RB:** Humor.

**MR:** However, it's always a cutting humor, where you force the viewer into an uncomfortable position. Your film *Scratch an Aussie* [cat. no. 22] is an excellent example. While we viewers giggle about the content—the inane complaints of the white psychiatric patients—we're simultaneously bombarded by racist jokes about Aborigines that leave us aghast. Through humor, you force viewers to confront their own biases about race.

You also often play with the concept of "authenticity." Several of your early works, like *Prospectus.22* [cat. no. 7] and the "Text Ya" series [cat. nos. 3–6], utilize the symbols associated with "authentic" Aboriginal art: stenciled boomerangs and handprints, the letter *E*, dots, and so on. Yet you reference this "authentic" style in a humorous way, in a "Pop art" (aka "inauthentic") way so that the resulting symbols are visual parodies of the original. Can you explain this ongoing dialogue between "authentic" and inauthentic Aboriginal art?

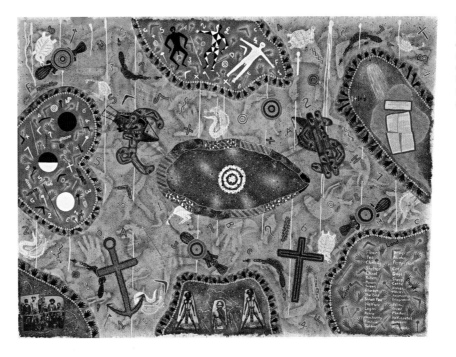

Richard Bell, *Crisis: What To Do about This Black and White Thing*, 1991. Synthetic polymer paint and collage on canvas, 70 ⅞ × 98 ½ in. National Gallery of Australia, Canberra; Purchased 1991. Courtesy the artist and Milani Gallery, Brisbane

**RB:** I call it my "ooga booga" style. [Laughs] But look, along with the authenticity of Aboriginal art, even the authenticity of artists is open to question; that is, whether the artist is a "real" or "authentic" Aboriginal. Many blackfellas who, like me, come from urban areas of the country apparently don't qualify as Aboriginal. We're not allowed to make "Aboriginal art" because that would make our work derivative. Never mind that almost all western art is derivative. Yet white artists are celebrated for "appropriating" Indigenous art.

**MR:** Yeah, like Imant Tillers and Jackson Pollock, for instance. So, from 1994 to 2001, you took a hiatus from the art world. Why was that?

**RB:** Basically, I just ran out of issues, and success scared me. But I also stopped making art around this time to concentrate on raising my two youngest children, Marshall and Sissy, who

were seven and six then. Another child, Sarah, was born three years later. During the last three years of that "sabbatical," I learnt more about myself than during any other period of my life. I believe this is what set me up to make a successful comeback to art-making.

**MR:** Was there an event or specific reason that led you to decide to produce art again full-time in 2001?

**RB:** My friend Tiriki Onus convinced me to have another crack at art-making. This was after a huge drinking session that preceded the opening of his father's retrospective at the Museum of Contemporary Art in Sydney.

**MR:** You certainly came back with a bang. Just two years later, you won one of Australia's most prestigious art prizes, the Telstra National Aboriginal and Torres Strait Islander Award, for your painting *Scientia E Metaphysica (Bell's Theorem)* with its central text reading "Aboriginal Art—It's a White Thing" [see illustration on p. 49]. It was also accompanied by a manifesto you wrote called "Bell's Theorem." Can you tell me more about that painting and the content of the manifesto?

**RB:** "Bell's Theorem" was a piss-take of the anthropological requirements for Aboriginal art to have this fucking story. I did a piece of art that wasn't Aboriginal art, but I gave them a story. I was demonstrating that "Aboriginality" is not innate and natural to Indigenous Australians but rather a projection onto them by white Australians who are seeing the work only through white eyes.

**MR:** In 2001, you began sampling images and styles from other artists. Your "Desperately Seeking Emily" series (from 2001) was an homage to the famous Aboriginal painter Emily Kam Kngwarreye; "Made Men" was appropriated from Lichtenstein's work. You've also directly quoted from Tillers and Colin McCahon, the former most famously in your 2002 *Bell's Theorem* [cat. no. 13]. Why this longstanding interest in appropriation as a strategy?

**RB:** Because I'm from the closely settled east coast of Australia, I'm not allowed to paint what's popularly called "Aboriginal art." Nor can I use the symbols and styles of Aboriginal people from remote, sparsely settled areas of northern Australia. Apparently, this would make my work derivative and hence diminished in importance, relevance, and quality. However, in western art, which appears to be almost entirely and increasingly derivative, no such restrictions apply. Quoting, citing, sampling, or appropriating pre-existing works even has its own movement: appropriationism. There's even a belief that "everything has been done before." (Which makes it cool to appropriate.) Consequently, I've chosen to quote, cite, and sample the works of many artists from around the world, just like most contemporary artists today.

Appropriation also extends to other art forms—hip-hop music, architecture, story-telling, etc. It's a deliberate tactic to use familiar imagery to carry particular messages. To drop the one-liner, the slogan, or other such visual equivalent of the thirty-second sound bite that's been so successful in advertising.

**MR:** Speaking of one-liners, what can you tell me about your "Theorem" series, in which each work features a central target and a powerful slogan, such as "We Were Here First," "Pay Me to Be an Abo," "I Am Not a Noble Savage," and so forth?

**RB:** I started making the "Theorems" in 2003. The first one was *Scientia E Metaphysica (Bell's Theorem)*. I've made fourteen so far, and I plan to make twenty.

**MR:** What are some of the other slogans?

**RB:** *Pay the Rent* [see illustration on facing page], which has smaller text that says: "You come to our home with nothing. We feed you. We clothe you. We give you shelter. When your boss comes your boss becomes our boss. You own all of us and all of our lands." It also includes the word "starboarders" in large black letters. Starboarders are people who stay with you in your home without paying any rent, taking over the television/radio programs of the household, deciding the dietary direction the

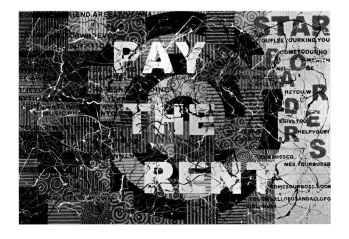

Richard Bell, *Pay the Rent*, 2009. Acrylic on canvas, 2 parts, 94 ½ × 142 in. overall. Courtesy the artist and Milani Gallery, Brisbane. Photo Carl Warner

family takes. They do nothing around the home but complain about everyone else. Basically, they take over the lives of the people with whom they live.

**MR:** So the starboarders are the white Australians or the colonizers who should pay in back rent what they've owed to the colonized Aborigines since "the invasion." Brilliant. In this exhibition, we've included *Wewereherefirst* [cat. no. 17], which reads, "There is no excuse for treating Aboriginal people badly. You have defied your upstanding citizens. You have defied the United Nations. You have defied the laws of humanity. You have defied your God. Why do you feel guilty?" We've also included *Contra* [cat. no. 20], which reads, "You don't have culture you can call your own. What our country imposes on you is all that you can claim. Everything else is stolen. Give it all back." The messages in the "Theorem" series are quite powerful—and the paintings are gorgeously executed. What can you tell me about the format, e.g., the licorice colors, the central target, the monumental scale?

**RB:** Well, each painting consists of two or three large panels, and then I use the color-block process of the "licorice allsorts" to create a "Pop" style. The target is important because from 2006 onward there was an intensely racist and harshly critical publicity campaign directed at Aboriginal men in particular.

It mostly centered on the Little Children Are Sacred Report, released in June 2007, which examined sexual abuse in Indigenous communities. This campaign eventually led, under John Howard's government, to the "Intervention" into Aboriginal communities in the Northern Territory in 2007. It made me feel like a target, and under suspicion, every time I stepped out into the street. And I wasn't the only one who felt like that. Brenda Croft noticed that a lot of the urban artists in the *Culture Warriors* exhibition were using targets, and for much the same reason—artists like Christopher Pease and Gordon Hookey.

**MR:** That's Gordon Hookey of proppaNOW, which is the artist collective you started in 2004 in Brisbane with Hookey, Jennifer Herd, Andrea Fisher, Tony Albert, and Vernon Ah Kee. What can you tell me about this group?

**RB:** It's made up of Aboriginal artists. We share many of the same aims and objectives. The name came from a discussion that Vernon, Jennifer, and I were having about the state of affairs in Aboriginal politics. We wanted to do things the "proper way," and we wanted to do it now. We noted that every revolution was started by a small group of people. Consequently, we set up proppaNOW as a vehicle to promote changes in thinking, among other things.

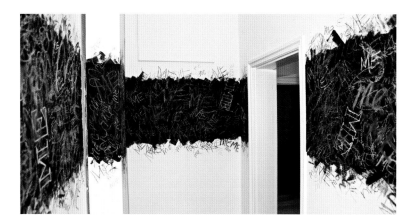

Richard Bell, *MeMe Dreaming* (installation view), 2010. Crayon on wall, dimensions variable. Linden Centre for Contemporary Art, Melbourne. Courtesy the artist and Milani Gallery, Brisbane. Photo Dean McCartney

**MR:** You've produced the most amazing projects together, the most recent of which was a group drawing show. For that you made an extended wall drawing called *MeMe Dreaming* [see illustration], which is an ode to Emily Kam Kngwarreye, right?

**RB:** The drawing consists of the word *me* written over and over in different colors. Each of the proppaNOW artists contributed to the piece, and it was part of our drawing show *Jus' Drawn* at Linden Contemporary Arts in Melbourne.

ProppaNOW has staged two major shows: *There Goes the Neighborhood* in 1996 and *The Amersham Trophy* in 1997, both at our studio in West End, Brisbane. We also provided work and the curatorial framework for a show at Tandanya Cultural Institute in Adelaide called *Putsch*.

**MR:** You've also recently collaborated, in 2009, with the Black Panther artist Emory Douglas on a two-man exhibition called *All Power to the People*. This was the first time you screened *Broken English* [cat. no. 23], right? What else did you include in that important show?

**RB:** In addition to the film, I presented one of my "Theorems", titled *I Am That Shallow* (2009), and a large painting called *Free Lex Wotton* [see illustration on facing page].

**MR:** Who is Lex Wotton?

**RB:** Lex Wotton led the Aboriginal response to the first coronial inquiry into the death of Mulrunji Doomadgee, an Aboriginal man who was killed in a prison cell in 2004 on an Aboriginal Reserve called Palm Island. The police station was burned down, and Lex is in prison while the policeman accused of Doomadgee's murder has been promoted and moved to the most desired destination in the Queensland Police Force, the Gold Coast.

**MR:** It must have been nice for you to get away from Australia last year to live in New York and gain some critical distance from all of that. What can you tell me about your experience living there for the first time?

**RB:** During those first few months, I loved the place. When I first got there, I was lost in the sheer size and overcome with feelings of unfamiliarity. Not wanting to be the first blackfella to be lost in New York, I began taking note of anything that could be a landmark. This isn't easy when the concrete canyons offer only slight variation to unfamiliar eyes, and the sun is in the southern sky rather than the northern. But navigation aside, I was struck by the different faces, the different races, short, tall, thin, not so thin, locals, and other visitors bustling and hustling around and about the city that never sleeps.

My first apartment was a tiny affair on the Lower East Side—way too small for me. Anyway, me being the luckiest man in all of North America at the time, my network of friends delivered me one of the best apartments in all of Harlem. Now before one goes sticking up their nose at Harlem, I shall remind you that Harlem was built for rich white people. Right on Riverside Drive it was, across the road from Riverside Park and on the ground floor. No six-floor walk-up for me.

The neighborhood was mainly black people from the Dominican Republic, but there were lots of Mexicans, Guatamalans, Puerto Ricans, and African Americans, as well as a sprinkling of white people. Indeed, there were three or four white families in our building. I loved living up there. It was like living on one massive Aboriginal reserve, only quieter. All the same characters and personalities existed there too.

One of the first things I noticed about New Yorkers was their comparative conservatism. Australia seems veritably socialist in comparison. And God is big there, just huge. This is especially so with the black people. I had to lower my expectations with respect to anything remotely progressive.

However, I wouldn't have been able to last the ten months if I hadn't had my daughter Sissy with me for five months or so. She was my contact with "back home."

As for art, I got to visit all the great museums and galleries. I probably saw a lot of great art but didn't recognize any of it.

**MR:** [Laughs] Did you produce a lot of work while in New York?

**RB:** Yeah, well, I made a bunch of paintings and produced a film called *Blackfella's Guide to New York* [cat. no. 26].

**MR:** What can you tell me about *Blackfella's Guide to New York*? What do you mean by the word "blackfella"?

**RB:** "Blackfella" is a term used by Indigenous people, both men and women, to refer to themselves. When I started making

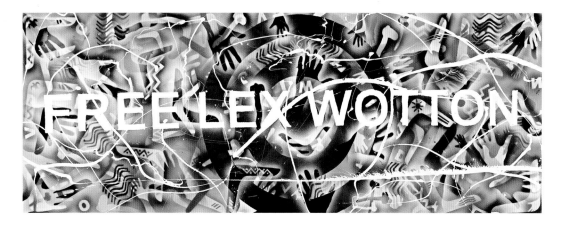

*Blackfella's*, I was really making it for my mates back home. I'd come to the city with my perspective, a non-native perspective. I saw things that natives [New Yorkers] have never seen before. I was curious about how people walked, how they talked, how they interacted with each other in various situations and circumstances, and in the differences between life in small communities as opposed to life in one of the biggest cities in the world. During the shoot, I spoke to a homeless Honduran woman in Harlem, hung around a newly commissioned mural by Shepard Fairey in the East Village, sat in confession for the first time at Saint Patrick's Cathedral, and went on a Harlem River cruise.

**MR:** With *Blackfella's*, it's as if you've reversed the anthropological dehumanization of "primitive" Aborigines by turning your gaze on the boroughs of New York, treating the residents as anthropological specimens from an Aboriginal perspective. It certainly puts the power back in your hands, doesn't it?

**RB:** Damn right it does!

Richard Bell, *Free Lex Wotton*, 2009. Acrylic on canvas, 35 ½ × 71 in. Courtesy the artist and Milani Gallery, Brisbane. Photo Carl Warner

# FOR WHOM THE BELL TOLLS— IT TOLLS FOR THEE [1]

Djon Mundine

I lived my first two years in a tent on the *yumba*, waiting for the white people to throw away enough corrugated iron sheets for our family—me, my brother, and my mum—to build a tin shack and move up in life—from a tent to a tin shack.

Richard Bell, 2010

I first got to know Richard Bell in 2000, when we were both more or less living on the streets around the inner Sydney suburb of Glebe. The city was alive with the hype and palaver of the Sydney Olympics. We were both in transit, personally and spiritually. Bell's career had stalled somewhat, and he was separated from his wife; I was unemployed, alone, penniless, and totally defeated. I had been invited to stay with photographer Michael Riley at his public-housing flat. Riley's health had begun to decline and he would die in 2004. Later, when I went to Brisbane to work in 2004, I visited Bell while he was recovering from a bypass operation. In both situations, away from the art crowds, a more reflective, almost—dare I say it?—humble persona showed from behind the mask.

How many lives does a cat have? How many chances for rebirth can a man have? In Bell's case, he has survived being born into poverty and then becoming an orphan; running a tourist business that failed; struggling through a marital separation in 2000 and a heart bypass operation in 2004. With great determination, willpower, self-belief, and a lot of luck, he went on to win the Telstra National Aboriginal and Torres Strait Islander Art Award for 2003.

\* \* \* \* \*

In 1952, Franz Fanon argued that in the post-colonial state, a national culture goes through three movements: first, the imitation of the culture of the imposed colonial power; second, the rejection of this culture and the idealization of the colonized people's historical forms to the exclusion of all others; and third, the arrival of a mature rationalization of both historical and current influences to a true societal expression and self-image. The histories of Aboriginal art can be divided into five overlapping, blurred-edge phases that follow Fanon's theory to some degree. Market-driven and stemming from European historical conceits on the one hand, this art offers up Aboriginal icons, ideas, and morality on the other.

The first phase in the histories of Aboriginal art spans the period from the beginning of time through the arrival of Asian visitors from the north—beginning, at the latest, in 1700—and the advent of the British colonists in the eighteenth century, up to the end of World War II. During this time, with few exceptions, Aboriginal people and their art were labeled "primitive."

When Europeans arrived in Australia to settle more permanently in 1788, it is estimated that there were between 318,000 and 750,000 Aborigines in the country. The Indigenous people spoke four hundred language groups that served many societies with differing experiences, geographical settings, and forms of

1. "No man is an island, entire of itself; every man is a piece of the continent, a part of the main. If a clod be washed away by the sea, Europe is the less, as well as if a promontory were, as well as if a manor of thy friend's or of thine own were: any man's death diminishes me, because I am involved in mankind. And therefore never send to know for whom the bell tolls; it tolls for thee." John Donne, "Meditation no. 17," *Devotions upon Emergent Occasions*, 1624.

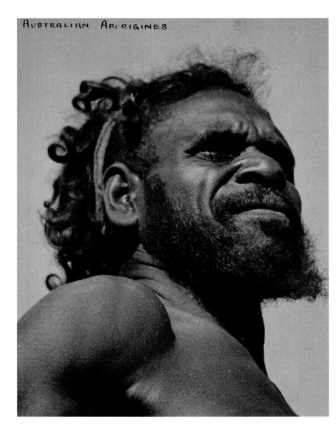

AUSTRALIAN ABORIGINES

Jimmy Gwoya Djungarrayi
(known as "One Pound
Jimmy"). Portrait by Roy
Dunstan, 1935. State Library
of New South Wales

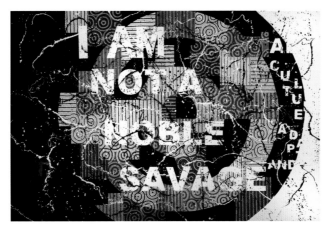

Richard Bell, *Life on a Mission
(Bell's Theorem)* 2009. Acrylic
on canvas, 2 parts, 94 ½ × 142
in. overall. Courtesy the artist
and Milani Gallery, Brisbane

artistic expression. The British settlers treated all these people,
regardless of their innumerable differences, as a common
non-European type; as the "other." Early images of Aborigines
produced by the settlers only served to emphasize this concept:
the Indigenous as "noble savage."

The most famous of these images from the post–World War II
time was a photograph of an Anmatyerre-speaking man from
the center of the continent called One Pound Jimmy, or Jimmy
Gwoja Djungarrayi. In the fashion of the 1930s, photographer
Roy Dunstan was looking for the definitive "primitive" stone-age
type. He thought he had found this in Jimmy. In 1936, a cropped
image of Jimmy's head and shoulders appeared on the cover
of a travelogue magazine called *Walkabout* that in 1950 was
adopted by the Australian Postmaster General for the eight and
a half pence stamp and then, in 1952, for the two shillings and
six pence stamp.[2] (It remained in use until 1966, when Australia
changed to a decimal currency system.) The image, which still
exists on the reverse side of the Australian one-dollar coin, had
a wide effect in defining what an Aboriginal man looked like.
As a result of its widespread use, at the end of this period an
Aboriginal was a noble savage from the desert!

The second phase in the histories of Aboriginal art began in
the 1950s and was marked by the "discovery" and marketing

2. About 85 million copies of the stamp were sold, an amazing number of
   images in a pre-internet world.

19

of Aboriginal bark paintings from Arnhem Land in the north of Australia. It was then, too, that the proposition was made that Aboriginal art is art with a capital *A* and possibly that it is contemporary art. However, it was not until the late 1950s that Aboriginal artists were first named in exhibitions; until then (with a few exceptions such as watercolorist Albert Namatjira), they had remained anonymous.

In 1958, the Art Gallery of New South Wales started to collect totem-pole sculptures and bark paintings, and Aboriginal art left the discipline of ethnography and became a form of "fine art." The fact that these artworks are similar in form to western art (portable paintings on a flat surface) assists this recognition. A discussion then took place about how to fit that art into the system and history of western art: is it surrealist, minimalist . . . What is it?[3] No definition was arrived at, and today the art remains in the gallery, if a little uncomfortably, in an academic sense. One should of course realize that when we talk of art, when we learn about art, when we see art, it is white western art history that we see, framed by white western art institutions. By the end of this decade, an Aboriginal was an intelligent, mystical, Malay-like, sophisticated, sociable Arnhem Lander!

The third phase in the histories of Aboriginal art was marked by the "western desert dot and circle" painting-on-canvas movement, starting at Papunya, northwest of Alice Springs, from the early 1970s onward. By this time, the Beatles and the Rolling Stones had toured Australia for the first time (1964–65), and Aboriginal people had received the right to vote as citizens of the nation (1965) and were first recognized and counted as human beings in the Australian population census (1967).

Although anthropologists had collected drawings on paper, cardboard, and other flat surfaces for some time, these were seen as curiosities and not art. As the artists of Papunya moved from ochre paints and discarded carpenters' off-cuts to acrylic commercial paints, art board, and fine canvases, their works were sold as "art," if initially somewhat

unsuccessfully. By the end of the 1970s, the artists were working on large-scale, canvas compositions. Discussion arose as to what to name this art movement. Attempts were made to define it as pointillist, religious, spiritual, narrative, abstract, or conceptual.[4] Commentators fell back on calling it modernist though it did not really fit the description. As such, it began to be included in various major exhibitions, such as the Perspecta Australian Survey and the Biennale of Sydney. (Incidentally, around the same time, in 1971–72, Indigenous American Lloyd E. Oxendine opened the American Art Gallery in SoHo to showcase contemporary Native American art—with mixed results.)

The decade of the 1970s was an exciting time in Australia, with the election of a visionary Labor government that declared that Australia would be judged for its treatment of Aboriginal people. Following the Vietnam War protest movement of the 1960s, a new generation of Aboriginal youth stepped up to press for human rights and land rights and to address other grievances. Establishment of the Aboriginal Medical Service and the Aboriginal Legal Services (1971) in Sydney both began as grassroot actions and then spread across Australia as institutions. The Black Theatre in Redfern began in 1972.

Many of the new campaigners were students influenced by the Black Power movement in the United States. Aboriginal Charles Perkins and other university graduates led a non-violent "freedom ride" bus trip through rural western New South Wales in 1965 to expose racist attitudes and illegal restrictions on Aboriginal people. By the 1970s, a younger generation looked to the writings of Malcolm X and Stokely Carmichael and to the idea that Aboriginal problems could be solved through political and practical action by Aboriginal people. For many in Brisbane, Melbourne, and Sydney, this was a serious movement. For others, it never went beyond big Afros and black leather jackets, an affectation of dress and mannerism establishing positive group identity and cohesion (see Bell's Afro in *Pigeon Holed*; cat. no. 1). Still other Aboriginal people refused to be merely American clones. As a result of numerous protest marches and lobbying of the government, a form of land rights was

3.   Douglas Stewart, writing in *The Bulletin* (1 July 1959), took this negative stand: "the 17 grave-posts . . . make a somewhat bizarre display . . . and most people, admitting that the poles are delightful in themselves, will wonder if the proper place for them is not the museum . . . These Melville Island posts, though they have definite artistic merit of an elementary kind, are really more in the nature of ethnological curiosities than works of art." James Gleeson, writing for *The Sun* (18 July 1959), reacted differently: "Whatever their symbolic significance might be they represent an ensemble of abstract shapes of considerable aesthetic appeal. The very limitations of the technique and the restrictions imposed by the media produce a fine unity of design despite the fact that no two posts are identical in shape or decoration. Even in the artificial atmosphere of an art gallery they are impressive, for the painted posts stand about the grave in a protective ring, forming as it were, a barrier between the world of living reality and the shadowy world of the spirit." Both cited in J.A. Tuckson, "Aboriginal Art and the Western World," in R M. Berndt (ed.), *Australian Aboriginal Art* (Sydney: Ure Smith, 1964).

4.   "For better or worse, it is the strongest and most beautiful show of abstract paintings I have seen in a long time." Terence Maloon, "Aboriginal Paintings: Strong and Beautiful Abstracts Survive the Cultural Dislocation," *The Sydney Morning Herald*, January 1982.

granted to Aboriginal people in the Northern Territory in 1978. An Aboriginal was now a demanding, aggressive, angry Black Power brother!

In Aboriginal Brisbane of the 1970s and 1980s, artistic expression had a defined purpose: to achieve some form of economic independence and to express a strong Aboriginal identity (and male pride). Political figures such as Pastor Don Brady encouraged men to assert their Aboriginality (and maleness) by playing didgeridoo, performing traditional dances, and painting in a generic, "traditional" style (X-ray animals, fish and birds, cross-hatching, and dotting). Interestingly, nearly all (including the Bell brothers) avoided painting in the picturesque watercolor landscape style of successful Aboriginal artists Albert Namatjira and Queensland landscape painter Joe Rootsey, perhaps seeing these artists as working in a non-Aboriginal, inauthentic style. This group activity enacted a form of male-bonding exercise, if unconsciously, but female artists, both black and white, were also making political art. Aboriginal poet Oodgeroo Noonuccal (Kath Walker) had been a forceful political activist through the 1960s and in the latter part of her life produced propaganda poetry. The Watson family, which included ballerina Rosslyn—one-time performer with the Dance Theatre of Harlem—actress/storyteller Maureen, and visual artist Leila, made their political statements through film, theater, music, and radio.

Richard and Marshall Bell came out of these times. At this stage, Marshall was the more accepted artist. Both made "tourist" paintings to earn a living and to state a position: they wished to do something that had more artistic, social, and political credibility. Honing their self-taught draftsmanship and painting skills during this period, they sold their paintings at tourist outlets, the government-funded Queensland Aboriginal Creations, and the One People of Australia League (OPAL).

The fourth phase in the histories of Aboriginal art comes in the mid-1980s with the re-emergence of the art of the southeast and the beginning of "urban Aboriginal art." Although Aboriginal people in the southeast have expressed themselves through a number of practices, their work was never widely seen as art but rather as a kind of craft practice or folk art. The 1984 *Koori8* exhibition—an examination of this new generation of "urban" Aboriginal artists—set the scene. Influenced by post-colonial writing and the work of Jean-Michel Basquiat, the artists of the 1980s generation generally attended western art schools and/or used western materials, concepts, and references to tell their Aboriginal stories.

During the fifth phase in the histories of Aboriginal art, beginning in the late 1980s, Aboriginal people began to curate, write about, and gain a small degree of control over the marketing and interpretation of their own culture.[5] Following the success of the Campfire Group—a collective of Indigenous and non-Indigenous artists working collaboratively in the studio, led by non-Aboriginal artist Michael Eather, Marshall Bell, Laurie Neilson, and others—the present-day Fire-Works Gallery emerged as a commercial space in Brisbane in 1993. The collective nature of the Campfire Group was in contrast to the model of the Boomalli Aboriginal Artists Cooperative in Sydney. Shunned by commercial galleries, funding bodies, and art institutions, the latter group formed in 1987. Exclusively Aboriginal in membership, administration, and board, Boomalli refused to take part in the combined (Aboriginal and white artists) *Balance* exhibition at the Queensland Art Gallery in 1990. I, and the Boomalli artists, objected to the central premise of the *Balance* exhibition, which was that in using western materials Aboriginal artists were collaborating with white Australian artists. Even more galling was the implicit idea of the exhibition that Aboriginal artists needed "white Australian" artists and artwork to make up for deficiencies in the Aboriginal artwork. In response, a prominent Aboriginal leader labeled the Boomalli artists "young black fascists."

If there was a colonial divide in Fanon's Caribbean, there certainly existed such a divide among Aboriginal Australians. The Boomalli group attempted to encourage like-minded artists in the other major cities to follow its lead, but to little immediate effect. Others took a different route and moved to stay above identity politics and the shortcomings of its debate. Both Brisbane-based painter Gordon Bennett and filmmaker/

5.   Later, in 1994, I collaborated with Fiona Foley (Boomalli co-founding member) at Sydney's Museum of Contemporary Art to curate *Tyerabarbowarryaou II: I Shall Never Become a Whiteman II* for the 5th Havana Biennial.

photographer Tracey Moffatt (then in Sydney) made their positions clear: they saw themselves as artists first and did not wish to be ghettoized and restricted through labeling. A binary line of shallow thinking developed—a division between the art of "traditionals" (or "ooga booga") and those who were "urban" (or modern). Thus there is an irony in Bell's parodying of the "ooga booga" dot paintings by the traditional Aboriginal people from the central deserts, and then later working with "white man" Ben-Day dots à la Lichtenstein.

Both Bells were involved in the efforts of Aboriginal artists to gain control of their industry and the direction it was taking in the late 1980s, which in Queensland led to the development of the *Balance* exhibition, the Fireworks artists collective, and to their inclusion in the 1992 Biennale of Sydney. The brothers, especially Richard, enriched their practical skills with their new experiences of contemporary art practice gleaned from the Aboriginal art world, in conversations both inside and outside the Campfire Group, as well as from discussions concerning conceptual and performance art at Brisbane's Institute of Modern Art. At this time, the museum was directed by Nic Tsoutas, who had introduced Bennett to performance art and then encouraged Bell to experiment with installation, video, and performance. An Aboriginal at the end of the 1990s was an urbane, articulate, contemporary artist!

* * * * *

At the 2010 Adelaide Art Festival, on a panel highlighting the proppaNow group, Bell talked of the tension that Aboriginal people feel in this society, a tension that often comes out as anger and an aggressive attitude. Aboriginal men are often defined not in relation to their actual personalities but rather in terms of the straitjacket they are forced to wear by society. A colloquial "white Australian male" saying (especially after a few beers) is "We shot the 'Abo' men and fucked the women and are now fucking the race out of existence." While non-white, non-western men are stereotypically cast as effeminate (Asian) or hyper-sexual (African American), Aboriginal men are trapped somewhere in between. In the master-slave relationship, both parties reflect and recognize each other. In the colonial situation, subjugated males are totally invisible. To cast Aboriginal men as desirable is to see them as human and natural, but this means in effect to relinquish control.

We are told to think positively and work toward reconciliation, to forgive the fact that we have had everything taken from us not once, not twice, but many times. We are told we must never feel hatred.

> *We must never hate.*
> *But how can we not hate?*

From the late 1880s until the post–World War II period, the decade of Bell's birth, nearly all Aboriginal people were legally bound and held under the Protection of Aborigines Act that allowed each state to administer Aboriginal monies, including wages, and decide how it was spent. The states also controlled where they traveled, whom they married, what properties they could own, where they could live (on a reservation, or not), whether they could drink alcohol, and their right to vote in state and national elections. A type of apartheid existed where one could apply for an exemption to live, work, and handle one's own monies and affairs—so long as one agreed, in essence, to be an Aboriginal no longer but rather be assimilated into "white Australian" society. (Many Aboriginal people working in the cattle industry applied for this exemption.)

> *Sent us off to mission land.*
> *Taught us to read, to write and pray*
> *Then they took the children away,*
> *Took the children away,*
> *The children away.*
> *Snatched from their mother's breast*
> *Said this is for the best*
> *Took them away.*

Archie Roach, excerpt from
"They Took the Children Away," 1990

Until the 1970s in Australia, a policy of church and state was enforced whereby children of mixed Aboriginal-European parents were removed "for the benefit of the child" to be placed in institutions where they would be socialized to be good white Australian citizens. As the Bell brothers discovered at the Retta Dixon Home for Aboriginal children of mixed descent in Darwin, these are generally lonely, harsh places—places of abuse and deprivation. When Opposition members demanded that the government apologize to the Stolen Generations, expressing true empathy and sorrow, the government, not content with playing semantic games, rolled on the floor in laughter. Then, immediately after Prime Minister Kevin Rudd's moving historic apology in 2008, lest we felt reassured, the leader of the Opposition, Dr. Brendan Nelson, warned Aboriginal victims not to expect any form of compensation (financial or otherwise) and said that Aboriginal people must clean up their act in regard to the criminal lives they led.

The child is father to the man. There is of course a luminal point of joking, of becoming "a" fool rather than "the" fool. You can deal with these challenges with bravado and violence or by joking the uneasiness away. Or you can find somewhere in the middle. Bell has opted for this middle ground, emphatically exposing the injustices while always maintaining his sense of humor.

*All the children come back*
*The children come back*
*The children come back*
*Yes I came back*

Archie Roach, excerpt from
"They Took the Children Away," 1990

# SCRATCH AN AUSSIE

Richard Bell

Photo Naomi Shedlezki, 2009

It has been said that my politics resemble those of people who were involved in the Black Power movement of the 1960s and 1970s. I believe, however, that any classification of my politics is just another means of disempowering Aboriginal people. I'm not alone in holding these beliefs. We believe in the right to self-determination. We believe in land rights for Aboriginal people. We believe we have inalienable rights to the lands, including the sub-surface; to the rivers and creeks; to the seashores and the seabed; and to the air and airspace. We believe in our right to sovereignty and other symbolic issues.

It needs to be said, right here, right now: self-determination as a policy is *not* a failure. It is not a failure simply because it has *never* been tried in this country. Certainly, there have been countless watered-down versions of self-determination attempted throughout the country. All of them ended up owing their demise to the government.

Twenty-twenty hindsight has demanded re-examination of many issues that pose serious questions for our communities. For instance, how do we Aborigines maintain our culture yet move forward into the twenty-first century? It is obvious that there is always a price to pay, and it is no different in the case of modernizing Aboriginal communities. In negotiating our move forward, we must first establish what is negotiable.

So what issues are negotiable and what issues are non-negotiable? I believe that the acts of sharing and the principles of conservation within Indigenous societies are non-negotiable issues. On the other hand, I believe that the practice of arranged marriages is negotiable. Sure, there are many, many other issues, but let's stay with this momentarily. This practice of arranged marriages, in my opinion, does little more than alienate the youth from the older generations. The young males are angered that there are no girlfriends for them while the old men have many. Given that modern life has visited them, the girls don't want some old wrinkly dude when they can access the hottest guys in the 'hood. The young either reject the whole of their culture on the basis of this one weakness, or they contemplate other ways to overcome their dilemma. Like leaving the community or suicide.

A crucial question is how do we define what is Aboriginal? What makes one group or person Aboriginal or not? Or to ask another question, what makes one group or person more Aboriginal than another? Indeed, can we say that someone is more or less Aboriginal? At the moment, we define ourselves as being Aboriginal without degrees of Aboriginality. You're either Aboriginal or you're not. We are also defined anthropologically, which raises questions of authenticity and classification. To some people, if you have one non-Aboriginal parent, you're not Aboriginal. If you live in the city, you're not Aboriginal. First we need to take ownership of the conversation around our identity. Then we may need to change the way we define ourselves. What I will show next is that this question is one of survival for the Aboriginal people.

Aboriginality is not simplistic—it is full of complexity and nuance. Anthropology wants us to remain "authentic" (read "primitive") so we can fit the systems of classification they've set for us. That is simplistic. But we have evolved and are evolving. If we can't be Aboriginal *and* modernize, then we're doomed to extinction in a form of collective suicide. And if we modernize but can't retain our Aboriginality, then it's the same result. Cultural extinction. This is a question of survival. There are Aboriginal/Native peoples all over the world who are struggling with these very same questions.

Here's another question: why do foreign tourists (including European and North American tourists) seem to have a deeper appreciation of Aboriginal culture than the locals do? What is it these foreigners understand or misunderstand about Australian history that is different, even vastly different, from what is understood here? If it is different (and my experience is that it is), then one must question why it is different. Is it because the only Australian history that can be taught here in Australia is censored by an inherent and compelling desire to project and protect the virtue of the white settlers? Zealots from the right absolutely deny that Australia was invaded, and, apart from Aboriginal people and our supporters, the rest of the country agrees. They prefer to see it as "peaceful settlement."

Here's a case in recent Australian history that reveals the hypocrisy of that position. In the early 1990s, the Japanese tourism and investment boom in Australia was widely described in Australia as an invasion. I remember the hysteria that reverberated across the airwaves at that time. Old soldiers were talking to the "shock jocks" on the radio about the Japanese and how horrible they were during World War II. It was the time of Pauline Hanson, arguably Australia's best-known racist. In the minds of Pauline and her supporters, this was an invasion. Incredibly, they weren't the only ones who thought this way. A great many Australians agreed with them. Apparently, the little treasures objected to non-English shop signage and also to large numbers of non-white people roaming freely around the countryside unencumbered by police. This was a resuscitation of the White Australia policy and the fear of the "yellow peril." Indeed, they felt threatened by these polite, law-abiding people who were entirely unarmed. They were just people who thought that Australia was such a great place to visit that they came here in droves. The Japanese weren't going around forcibly removing people from their homes, claiming land for the emperor or digging gold from them thar hills. Why then do these same white Australians find it impossible to believe that their ancestors invaded this country? Why can't they see that the Aboriginal belief that the English invaded Australia is a valid one?

When the British arrived in Australia, the view espoused was that Australia was uninhabited. It was *terra nullius* and could therefore be settled rather than invaded. But of course, we all know that's not true; it was never true. It was acknowledged by Captain Cook and Governor Philip and, more recently, by the High Court of Australia. This myth of *terra nullius* is at the heart of Australia's collective amnesia regarding what really occurred.

The way Australians perceive their history and themselves is at odds with how the rest of the developed world perceives the history of Australia and its people. Either the civilized world has got it wrong, or the version of history that is taught here is bunk. To believe that the prevailing white Australian version of Australian history is correct is not a rational option.

White Australia could do itself a huge favor by dropping its irrational desire to attach "white virtue" to its forebears and see if it can simply accept that there was some bad shit that happened way back when. This issue needs to be widely discussed and debated. Unfortunately, the colonization of Australia is not considered a property issue. It is presented as a race issue, and any debate about race is stifled. Ordinary people are afraid to tell it like it is because of repercussions that are considerable and very public. To be called a racist is a very serious charge, especially when the person is in a public position. But whenever anyone suggests that some policy or person exhibits racist tendencies, the reply invariably mentions or blames political correctness, or left-wing ideologies. The dreaded P.C., political correctness, is not the only weapon that the right uses to bludgeon dissenting points of view. The attacks quickly become demeaning and personal. One's view is subjected to ridicule; criticism is couched in terms that appeal to the lowest common denominator, and one is damned as being un-Australian. Thus, wishing to avoid charges of being P.C. and therefore "un-Australian," the respondent is totally disarmed.

"Political correctness" is a term created by a right-wing "think tank" to describe left-wing policies (e.g., affirmative action) that required people to be observant toward the requirements and aspirations of people in more needy circumstances. What's wrong with not being, or not wanting to be, a racist, or a sexist, or a homophobe? The original purpose of P.C. was honorable, considerate, and thoughtful. It became unworkable because some people became overzealous. Inevitably, this overzealousness became intolerable, defeating its purpose and ironically perpetuating the opposite response in many people.

The right lambasted and lampooned innumerable examples of sheer idiocy, and correctly so. However, after perfecting the art of P.C. bashing, the right has built on that hugely successful venture and continued upon that process, which seeks to silence any and all opposing opinion, especially left-wing ideology, even so-called "soft left" ideology. This process

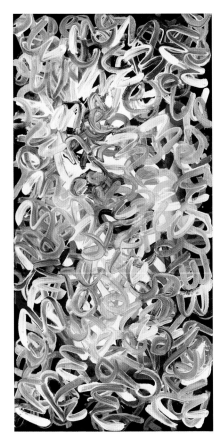

From **Psalm Singing Suite** (cat. no. 19)

is extremely effective in stifling debate, which is its entire purpose—because to stifle debate is to perpetuate the existing dogma while foreclosing on any possibility of a progressive approach or even a compromise.

At the same time as this phenomenon was occurring, Australia was experiencing an explosion in popularity of and participation in right-wing Christian fundamentalism. This was manifested by the emergence of groups like Hillsong and, more recently, the Family First Party. There is even a Christian group that operates openly within the parameters of the Parliament of Australia (which is supposed to have a separation of powers between church and state). These groups, and others of the Pentecostal persuasion, have underpinned the nation's abrupt swerve to the right during the last decade and a half.

The right has ruthlessly exploited this resurgence of interest in Christianity, accompanied as it is by its intrinsic conservatism, through continually referring to or calling upon a return to "traditional values"—code for White Anglo Saxon Protestant values.

This strategy of belittling and besmirching the reputations of dissenters has been practiced and repeatedly acted out so heartily that a hitherto unattainable level of excellence has been achieved. The process has forged a modern mantra, a chant that rails against the dreaded political correctness, followed by a syrupy homage to the egalitarian and caring "Ordinary (Christian) Australian" who couldn't possibly be racist and a rant about the betrayal of the white race and its Christian "values."

A similar strategy is used to stymie discussion of Australian history that raises contact between Aborigines and the white "settlers." Discussion of Aboriginal history ceases immediately when someone utters the words "Black Armband history,"[1] thus closing off any chance of arriving at a compromise. The fervor that the right shows in rooting out the so-called Black Armband view of history is vigorous, to say the least. One could even say it borders on zeal. Its champions are generously rewarded for their efforts with positions on various Statutory Boards, etc.—for

example, Mr. Keith Windshuttle's appointment to the Australian Broadcasting Commission. How dare those pesky Aborigines question the virtue and morality of the English settlers and their fellow travelers from the UK and Europe? It was the Christians who decided to "save" them and keep them alive. They should be grateful. Yes. It angers the right and their lackeys that Aboriginal people are *not* grateful for being conquered by the English, who, the right would have us believe, are the kindest, most humane colonizing power in the history of the world. They were Christian, weren't they? Protestant Christian, were they not?

The ruthlessly executed process described above mangles freedom of speech. It seeks to belittle people with opposing views by making personal attacks on them. It tries to question their opponents' loyalty to certain "national values." It queries whether the voices of dissent support Christian values. It absolutely must be "named."

I hereby officially name this process. I give you "Psalm Singing."

Psalm Singing, or P.S., allows Australians to deny the existence of racism in Australia. "If you scratch an Aussie, you scratch a racist." The right would have us believe that this famous old adage that has held true for the country's history since 1901 has suddenly been made redundant and inappropriate because racism has been eradicated. Unfortunately, however, a new malignant and highly contagious form of racism has been emerging in Australia for decades. And the symptoms are invisible to the victim. Nevertheless, the most prominent symptom, denial, is blatantly obvious to the unafflicted. The victims of this racism deny the humanity of the Aboriginal population. Deny that there was any injustice perpetrated against Aboriginal people. Deny that injustices are still occurring. Deny opportunities for the Aboriginal population to advance. Deny the delivery of basic services to Aboriginal communities, such as running water, sewerage, electricity, education, health, housing, policing, etc. Deny that the denial of basic infrastructure (which, incidentally, is provided free to white communities) renders these communities dysfunctional.

1.   The term was coined by Geoffrey Blainey, an Australian historian who was "oft quoted" by then Prime Minister John Howard. Howard once famously said on television, "I don't believe in the Black Armband version of Australian history."

This neo-racism has a name—Australian racism, or as my friend the artist Vernon Ah Kee calls it, "Austracism."

Naturally, Austracism ostracizes all forms of dissent from minority groups in order to maintain and perpetuate a chiefly Anglo-Saxon, Christian, market-driven position that firmly entrenches and affirms white privilege. Austracism manifests itself as immigration policy, beach culture, alcohol management policy, mutual obligation policy, assimilation policy, and larrikinism. Make no mistake, Austracism is racism.

The racist tendencies and attitudes of the "Austracists" are invisible to the beholder. This explains why the right claims that racism has been expunged from the Australian psyche. Little wonder, then, that this insidious cancer in our society has been able not only to take root but to flourish uncontrollably (see, for example, the 2005 Cronulla riots).[2]

Austracism allows for television commentators to call a Muslim cricketer a terrorist. It allows for other such loutish and racist behavior to be described as the "larrikin spirit."

The Psalm Singers would have us believe that Aboriginal culture is to blame for dysfunctional Aboriginal communities. Indeed, the Australian government changed the Aboriginal Land Rights Act (1975) in 2006 after a vicious and sustained media onslaught that attacked Aboriginal people, Aboriginal culture, and Aboriginal men in particular. This campaign lasted longer than a year. The reasoning behind the change was that the act supposedly encouraged practices that led to mismanagement of resources and other such behavior. Communities were forced to yield freehold title to their lands, then required to lease the land to the government for ninety-nine years in exchange for the basic infrastructure that has, up to now, been deliberately withheld by the government.

Psalm Singing and Austracism. They are the right's weapons of choice. Used together, they are as powerful as they are destructive. For example, the right believes that multiculturalism has been a failure, and firing with both barrels (those barrels being P.S. and Austracism), they have convinced a large portion of the Australian population that it is a failure. In fact, nothing could be further from the truth. Multiculturalism is an outstanding and unmitigated success in Australia. Just look at it: we all eat pizza and pasta. We all eat kebabs. We all eat Asian food. Our neighborhoods often resemble a virtual United Nations. We work with a virtual United Nations. Look at the ethnicity of the top five hundred individual businessmen/women in Australia—it will give you a clue or two. We've done much better than almost every country in the world at embracing this issue. That's right. We're a world leader in the area of multiculturalism, and we shouldn't give up just because of the Austracists. It's easy to be negative about things; much harder to be positive.

Austracism justifies the belief among anglo-Aussies that they can overlook the fact that they too are "boat people." Austracism has blinded these people to the fact that Aboriginal people were here first. The evidence shows that we've been here for more than forty thousand years. And, as for us coming down from Asia via the so-called land bridge, why has there never been any evidence found in Asia of us being there that pre-dates the evidence found and documented here in Australia?

It is tragic that what began as a property dispute has turned into a racial conflict. This is our land. We were here first.

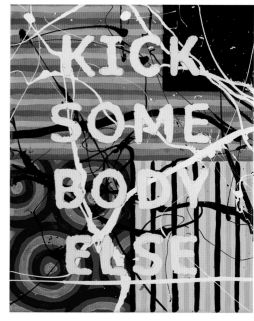

From **Psalm Singing Suite** (cat. no. 19)

2.  Do you remember the "We grew here. You flew here" crowd at Cronulla beach? In December 2005, more than five thousand young white people gathered at Cronulla beach (one of Sydney's southern suburbs) to physically remove Lebanese people from the beach over some random event. Sydney's leading shock jock had been involved in encouraging the young white kids to "reclaim" the beaches. Well, it turned ugly. Images of violent incidents filled the airwaves, flashing all over the world. Some young men were caught on CCTV and later charged and jailed. There was also an immediate and violent response from the young Lebanese over the next few days. Luckily, cooler heads prevailed and things were brought to hand but not before the world got a glimpse, or more like a lingering glance, at a violent and racist image of Australia. As an Aboriginal, I thought, NO! We grew here. You sailed here.

1

**Pigeon Holed**
1992
Series of 6 photos and 1 mirror with 7 text panels mounted on aluminum
31 × 118 in. overall (photos 30 × 20 in. each; text panels 8 × 12 in. each)
Courtesy Milani Gallery, Brisbane

In *Pigeon Holed*, Bell portrays himself in six
repeated images as an "angry black man" in
an effort to challenge the negative stereotype
associated with Aboriginal men. With missing
teeth, an Afro, and a belligerent expression, he
aligns current clichés for Aboriginal men with each
self-portrait: Drinker, Tailor, Sold Yer (phonetic
for *soldier*), Failure, Butcher, and Baker. On the
far right, a mirror bears the label "Trouble Maker,"
allowing the viewer to experience what it feels like
to be categorized derogatorily.

*Pigeon Holed* is about stereotyping and
categorization of people and things . . . A
very strong idea in this country is that of
the angry black man. And I presented this
ironically, this shot of a seemingly angry
black man. I wasn't angry though.[1]

Richard Bell, 2008

1.  Richard Bell, "Half Light: Portraits from Black Australia," artist
    discussion, Art Gallery of New South Wales, November 22, 2008,
    http://www.youtube.com/watch?v=QcTo3ugfc0k&feature=related

**DRINKER** **TAILOR** **SOLD YER** **FAILURE** **BUTCHER** **BAKER** **TROUBLE MAKER**

2

**L'ations**
1992–93
Acrylic on canvas, 3 parts
72 × 36 in. overall
Courtesy Milani Gallery, Brisbane

Main text: *ATION*
Text: *Cre, Civilis, Colonis, A, Nis, Proclam, Destin, Degrad, Exploit, Tor, Annihil, Degrad, C Modernis, Decim, Appropri, Sanit, Depriv, Devast, Pastoralis, Justific, Rationalis, Sol, Assimil, Integr, Expect, Self-determin, Reconcili, Aryanis*

In this work, Bell responded to then current views of self-determination and reconciliation with a colorful triptych that layers text onto a field of white dots and children's handprints in orange. The text appears purely decorative at first; however, word fragments slowly emerge: *civilis, colonis, exploit, assimil, self-determin*. These "ations" show the historical sequence, from top to bottom, of what has been happening to Aboriginal people and their culture over the last two hundred years. Placing *creation* at the top,

*devastation* in the middle, and *reconciliation* at the bottom suggests that Bell may subscribe to an overarching optimism. On the other hand, painting the words without their suffixes implies that their conditions are either completely meaningless or not yet complete.

By appropriating a painting style suggestive of the Western Desert Papunya Tula movement, yet adding a text signaling abuse in the language of the colonizer, Bell reminds non-Aboriginal Australians that they cannot have it both ways. Aboriginal art cannot be appreciated, and profited from, unless other meanings that lurk beneath the surface are acknowledged.

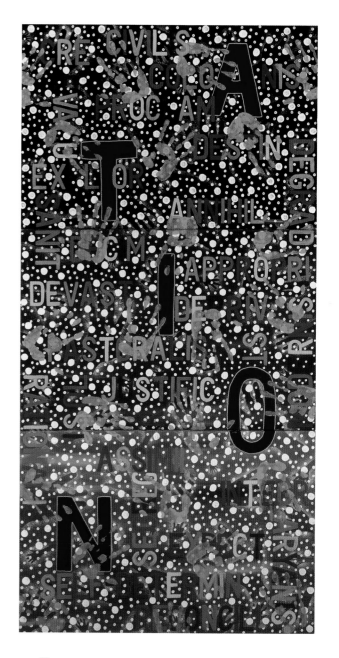

# 3

**Meeting**
1992–93
Acrylic on canvas
36 × 24 in.
Courtesy Milani Gallery, Brisbane

The fact that I have to use the language of the colonizer is a statement in itself. That I don't have the stories from the six tribes that I descended from is appalling.[1]

Richard Bell, 2002

Text: *Meeting, Meeting, Meeting, Meeting, Fullagoona, Regional Council, "Geelee Mob," Hosts Next Meeting, In Jillawaii*

*Meeting, No* (cat. no. 4), *Sword* (cat. no. 5)*,* and *Words* (cat. no. 6) were first exhibited in the exhibition *Text Ya* at Hogarth Gallery in Sydney in 1995. Working in earthy browns, reds, yellows, and white, Bell gestures toward the natural ochre palettes of Aboriginal artists whose works are typically marketed as iconographic illustrations of "dreamtime" stories. By adding a layer of text to this "ethnographic" background, however, he tells his own story.

Although Bell uses text as a shortcut to provocation, the words often have built-in contradictions. In *Meeting, No,* and *Sword*, he utilizes charged language with various degrees of ambiguity; some words will be understood only by very specific audiences. In *No*, words such as *noondu* ("unsweetened tea") and *boodjeri* ("nothing") would only be recognizable to Aboriginal people with knowledge of East Coast languages.[2] More familiar synonyms for *no* cover the canvas: *naaa, nil, nien, nyet, none, negative,*

*non, not, zero, zilch, zip, fuck-all,* etc. The effect is a resounding *no* that all Anglo-European viewers will understand, although what they may not discern is that they themselves are the subject of the painting's refusal. In the center of the work sit the words "No Good Gubbas." *Gubba* is colonial slang used by Aborigines to refer to a white person.

The "story" Bell tells in *Meeting* and *Sword* references contemporary issues affecting the daily lives of Aboriginal people. Since the referendum of 1967, which amended the Australian constitution on issues relating to Indigenous Australians, Aborigines have become increasingly frustrated with the minor steps taken on the issues of land rights, discriminatory practices, and preservation of cultural heritage.[3] During the late 1980s and early 1990s, mal-administrated government agencies, such as the A.T.S.I.C. (Aboriginal and Torres Strait Islander Commission), frequently attracted media attention for their wasteful "throw money at it" policies regarding Aboriginal affairs. Bell's painting *Meeting*—with references to the Fullagoona Regional Council, or "Geelee Mob," which would host the next meeting in Jillawaii—

advertises yet another agenda-less gathering of bureaucrats that would achieve nothing.

While the Australian government has provided no "voice" for young Aboriginal activists, *Sword* highlights the international movements and leaders, along with their weapons of choice (bayonets, a-bombs, cannons, daggers, and swords), who have taken action against oppressors, such as S.W.A.P.O (South West Africa People's Organization), Sinn Féin (linked to the Irish Republican Army), the P.L.O. (Palestine Liberation Organization), and the Red Army.

1. "Richard Bell Interviewed by Michael Eather," in *Richard Bell* (Brisbane: Fire-Works Gallery, 2002); reprinted in Robert Leonard (ed.) *Richard Bell: Positivity* (Brisbane: Institute of Modern Art, 2007), p. 77.
2. Richard Bell, personal correspondence with the author, May 2010.
3. The referendum of May 27, 1967, was overwhelmingly endorsed, winning 90.77 percent of votes cast and carrying all six states. As a result, the government was given constitutional power to formulate legislation concerning Aboriginal people (previously this had been the responsibility of state and territory governments). It also allowed Aboriginal people to be counted in the national census for the first time.

4

**No**
1992–93
Acrylic on canvas
36 × 24 in.
Courtesy Milani Gallery, Brisbane

Main text: *No, Good Gubbas*
Other text: *Nothing, Nil, Nien, Naaa, Nyet, None,*
*Negative, Non, Not, Zero, Zilch, Zip, Hollow, Minus,*
*Fuck-All, Alone, Noondu, Boodjeri, Vacuum, Flying*
*Pigs, Blot, Hen's Teeth*

5

**Sword**
1992–93
Acrylic on canvas
24 × 36 in.
Courtesy Milani Gallery, Brisbane

Main text: *Sword*
Other text: *S.W.A.P.O.* [South West Africa
People's Organization], *Cannon, Bayonet, Sinn
Fein, P.L.O.* [Palestine Liberation Organization],
*No, Ta, Live, Pen, Die, K.L.N.F.* [Karbi Longri North
Cachar Hills Liberation Front], *Rifle, Not.A, Or,
Dagger, A.N.C.* [African National Congress], *Red
Army, Zealots, A-Bomb*

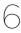

6

**Words**
1992–93
Acrylic on canvas
23 ¾ in. × 36 in.
Courtesy the artist and Milani Gallery, Brisbane

Main text: *Words*
Other text: *Peace, On, Cease Fire, Faqyasall, Bangu, Mine, Ytaert, Not a, War, Brains, Travel Allowance*

**Prospectus.22**
1992–2009
Acrylic, digital photographs, and barbed wire on canvas; 3 panels
96 × 180 in. overall
The James C. Sourris Collection, Brisbane

This work is a satire on colonization in the form of a monumental painting that incorporates a letter and draft treaty. The letter, which is addressed to the chairman of the People's Republic of China and signed by a consultant for the Pan Aboriginal Congress of Australia named Ian Di-Jinus (phonetic for "Indigenous"), offers "an equity partnership" in the development of the "island continent" of Australia. The draft treaty outlines the conditions for a shared sovereignty of Australia. Unlike in other colonized nations, there has never been an official treaty between Australia's Aboriginal people and the British Crown.[1] Bell's Draft Treaty concludes, therefore, that Australia's Indigenous people are free to form a treaty, on their terms, with whomever they wish. The main condition of Bell's treaty is as follows:

*Aboriginal groups will retain sovereignty over their chosen lands. They will receive 25 percent of the GNP each year and have guaranteed parliamentary representation totaling not less than 20 percent of the National Govt. Aboriginal rights will be protected under the Treaty and be outside the sphere of Parliamentary*

*responsibilities. Not less than 30 percent of total land mass shall be Aboriginal, including fertile sections of land, cities, towns and suburbs. All National Parks and World Heritage areas will be Aboriginal owned and controlled. All places with European names will be given Aboriginal names.*

Bell's *Prospectus.22* is reminiscent of a landmark 1963 petition sent in the form of a two-panel bark painting by the Indigenous Yirrkala community to the federal government to protest a mining company's seizure of their land (see illustrations). The community stated their claims on typed mimeograph paper that had been glued into the center of a bark painting, around which were earth-toned Aboriginal designs, such as schematic renderings of snakes, turtles, and fish. Likewise, throughout Bell's text painting he displays silhouetted "authentic" Indigenous renderings of boomerangs and children's handprints. Blood-dripped bullet holes (hence the ".22" in the work's title), each of which carries an image of Bell's face, are scattered throughout the painting. In the center is a symbolic bleeding crown of thorns in the form of barbed wire.

1. During the period of British colonial expansion, the British government acquired territory in several ways. If the British deemed a group of Indigenous people to have a "developed" civilization, then the sovereignty of the people was recognized and the British could only acquire the land derivatively through either conquest or negotiation. This occurred to varying degrees in Canada, the United States, India, and New Zealand. On the other hand, if the British found land to be occupied by Indigenous people they considered "less civilized," then such land would automatically become the property of the "more civilized" people. This is what happened in Australia with the British crown using the doctrine of *terra nullius*— meaning "land belonging to no one"—to justify its occupation. Aboriginal people have been fighting for the return of their land and the recognition of sovereignty ever since. See *The Senate Standing Committee Report—200 Years Later* (Canberra: Australian Government Publishing Service, 1983), pp. 35–37. Retrieved May 10, 2010, from http://www1.aiatsis.gov.au/exhibitions/treaty/200years.htm

Yirrkala Bark Petitions, 1963, various artists of the Yirrkala community. Original documents of the House of Representatives, Australian Parliament House

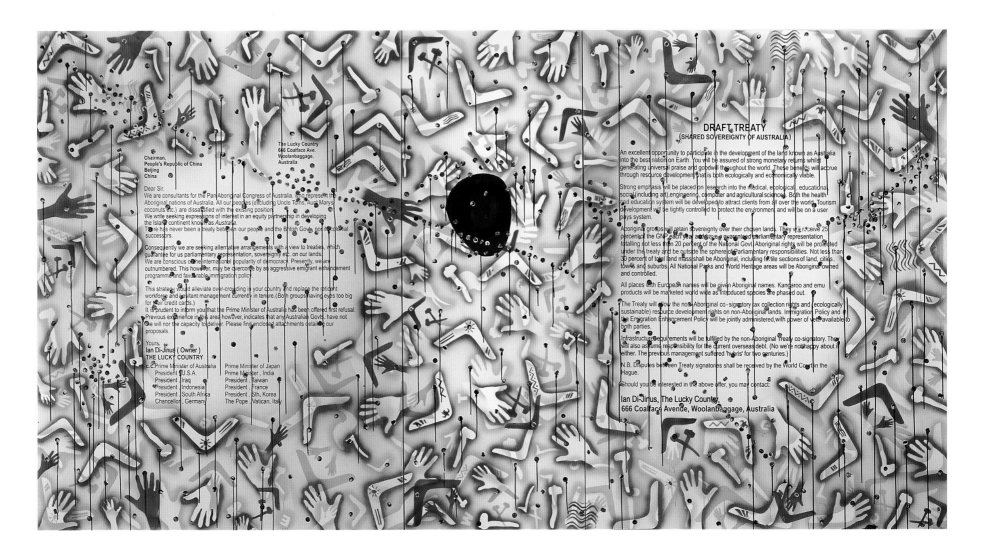

**Fuchen Messe**
1994
Acrylic on canvas
36 × 24 in.
Private collection, Brisbane

In 1994, Melbourne-based Gabrielle Pizzi Gallery's application to participate in the Cologne Art Fair was rejected on the grounds that it did not exhibit "authentic Aboriginal art" but rather "folk art."[1] Bell, who was then represented by Pizzi, considered this an affront to all Aborigines and, in 1995, presented an exhibition called *Text Ya* at the Hogarth Gallery in Sydney that included paintings—among them, *Fuchen Messe* and *Art Movements* (cat. no. 9)—made in direct response to the Cologne issue.

*Fuchen Messe*—phonetic for "fucking mess"—is a text painting that reads: "If Aboriginal art is folk, then German art is folk. The essence of 'seeing' lies within ourselves. Aryan art is not [sign for *greater than*] nor [sign for *less than*] non-Aryan art." With his typical sarcasm, Bell painted the work to look "authentic," replete with silhouetted handprints, boomerangs, and a geometric and dot matrix border. Similarly, *Art Movements* consists of a set of four panels, each with its own text: "Pre Aryanism," "Aryanism," "Pre Post Aryanism," and "Post Aryanism." These panels are then joined together with broken black and white triangular patterns, or what Nicholas Thomas terms, a "half-caste border."[2]

1. John McDonald, "A Snub for Contemporary Aboriginal Art," *The Sydney Morning Herald*, August 6, 1994, p. 13. The impudence of the Cologne Art Fair exhibitor selection committee to judge "authentic Aboriginal art" was especially ludicrous considering that *Aratjara*, a group exhibition of Aboriginal art, had toured to nearby Düsseldorf the previous year.
2. Nicholas Thomas, "Richard Bell's Post-Aryanism," *Art Monthly Australia*, March 1995; reprinted in Robert Leonard (ed.), *Richard Bell: Positivity* (Brisbane: Institute of Modern Art, 2007), pp. 75-76.

# 9

**Art Movements**
1994
Acrylic on canvas, 2 parts
47 × 30 in. overall
Private collection, Brisbane

As Bell became increasingly aware of western art history in the early 1990s, he began to take aim at the categorization of art movements within the canon—realism, impressionism, post-impressionism, cubism, and so on. From an Indigenous perspective, Bell postulates that there are really only four art movements: Pre-Aryanism, Aryanism, Pre-Post-Aryanism, and Post-Aryanism. The painting shown here was first exhibited in Germany; hence the use of the term "Aryanism," which recalls the socio-political agenda of the Nazi party. Bell asserts that of these four movements, we are currently experiencing the second phase, Aryanism.

10

**Untitled**
2001
Acrylic on canvas
35 × 24 in.
Courtesy Milani Gallery, Brisbane

**For the Gin Jockeys**
2001
Acrylic on canvas
35 × 24 in.
Courtesy the artist

After a seven-year hiatus, Bell returned to painting full-time in 2001 with a series of works called "Desperately Seeking Emily" that pays homage to the celebrated Aboriginal painter Emily Kam Kngwarreye. Bell admires her abstract canvases and appropriates her dot matrixes, drips, and swirls of color, as well as her use of hidden text. *For the Gin Jockeys* is part of that series, an entirely abstract work made using dozens of color drips and swirls while also adding into the mix the phrase "White girls can't hump." Clearly provocative, the phrase, along with the work's title, intends to invert a sexist and racist stereotype attributed to Aboriginal women. *Gin* is old-fashioned slang to describe an Aboriginal woman; a gin jockey is a white male who prefers Aboriginal women. Bell seems to delight in using such politically incorrect terms. *For the Gin Jockeys* can be considered his tongue-in-cheek challenge to all the gin jockeys who were the first to say "White girls can't hump."

I'll produce text and something visual and I'll whack some Pollock-style action painting over it. The same way that Emily [Kam Kngwarreye] used to hide her stories under the layers of paint and say "Whole Lot . . . My Country." That's my message too.[1]

Richard Bell, 2002

1.  "Richard Bell Interviewed by Michael Eather," in *Richard Bell* (Brisbane: Fire-Works Gallery, 2002); reprinted in *Richard Bell: Positivity* (Brisbane: Institute of Modern Art, 2007), p. 77.

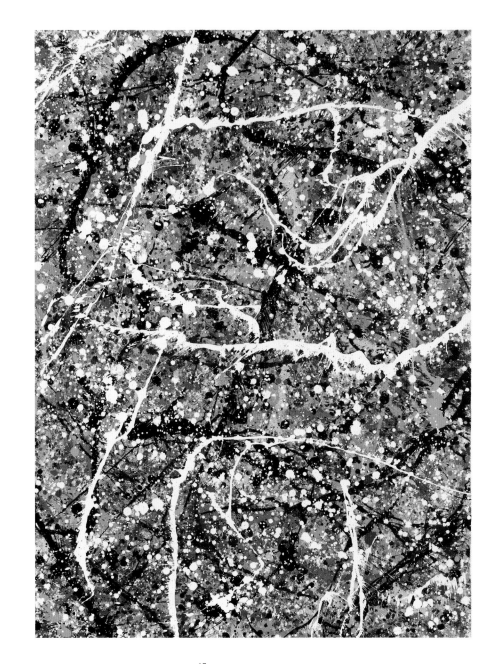

**In This Land**
2001
Acrylic and bitumen on canvas
54 × 36 in.
Collection Andrew Boe

In 1995, the issuance of a government report called
"Bringing Them Home" marked a pivotal moment
in the controversy about the Stolen Generations.
The report was written in response to efforts made
by key Indigenous agencies concerned that the
general public's ignorance of the history of forcible
removal was hindering the recognition of the needs
of its victims and their families and the provision of
services. Principal among the topics was whether
the removals constituted a form of genocide. *In This
Land*, with its text reading, "Genocide is not illegal,"
addresses this topic directly. Historical amnesia has
allowed people to deny and forget that genocide
is still being perpetrated throughout the world
and that it is not just a problem of the past. Using
a mixture of acrylic, gravel, and binder on canvas,
Bell denies that everything is all right by inflicting
abrasive materials and uncompromising text upon
the viewer. As observed by anthropologist Franca
Tamisari, the text in Bell's gravel works "protrudes
like a hardened scar on the skin,"[1] a reminder of
history's violent wounds.

1.   Franca Tamisari, "Showzoff and Positivity: It's Funny How Irony Works . . .
     Eh?" in Robert Leonard (ed.), *Richard Bell: Positivity* (Brisbane: Institute of
     Modern Art, 2007), p. 21.

**Bell's Theorem**
2002
Acrylic on 25 canvas boards
70 × 50 in.
Courtesy the artist

In *Bell's Theorem*, Bell takes his approach, medium, and title from Australian artist Imant Tillers, in particular, from Tillers's 1982 seminal essay "Locality Fails," which is notable for its refusal to privilege location and context with regard to Indigenous Australian art. Imitating Tillers's signature practice, *Bell's Theorem* is made up of boards in grid formation that bear the text "Locality Fails" and other words relating to the essay: "butterfly FX," "Godel," and "Chance." Prominently written in the center of the canvas is the phrase "Aboriginal Art—It's a White Thing," a statement by Bell intended to emphasize how Indigenous art is not only a phenomenon created by white anthropologists and art advisors but one that reduces Aboriginal art to dots and bark paintings. As he explains, "White people buy it, white people say what's good, what's bad. They sit in judgment." The slogan makes the point that Aboriginal art is a kind of projection made by white Australians, including Tillers.[1]

The title *Bell's Theorem* derives from Tillers, who references an obscure formulation from quantum mechanics with the same name. Tillers uses Bell's Theorem to "suggest that the conscious striving after the appearance of 'localness' could be an utterly futile and nonsensical activity."[2] In practice, this translates into Tillers's casual mix-and-match approach to history and cultural identity as he layers imagery stolen from Aboriginal and non-Aboriginal art onto mass-produced canvas boards in a manner that denies ethical concerns.

With *Bell's Theorem*, Bell wades into a complex debate about copyright and the borrowing of cultural motifs with cutting glee. While *Bell's Theorem* may at first look like one of Tillers's complicated works, Bell has actually stripped the imagery down to iconography, including the floating *E*s, which reference the shapes often used by Aboriginal artists to indicate animal tracks. In re-appropriating the master appropriator, Bell returns ethical concerns to Aboriginal art.

In 2003, Bell wrote a manifesto on Indigenous Australian art, which he titled "Bell's Theorem." Using graphs, lists, and analyses of institutional mechanisms, the text argues that Aboriginal art is sustained and defined by a white majority and not by those who produce it. That same year he also produced a painting titled *Scientia E Metaphysica (Bell's Theorem)* (see illustration on facing page) with the same central text, "Aboriginal Art—It's a White Thing," though in this version Bell's formal language is all his own. With this painting, Bell won the 2003 Telstra National Aboriginal & Torres Strait Islander Art Award, Australia's most prestigious Indigenous art prize.

1.  "Richard Bell Interviewed by Michael Eather," *Richard Bell* (Brisbane: Fire-Works Gallery, 2002); reprinted in Robert Leonard (ed.), *Richard Bell: Positivity* (Brisbane: Institute of Modern Art, 2007), p. 78.
2.  Imants Tillers, "Locality Fails," *Art and Text*, 6:51–60 (1982): 57.

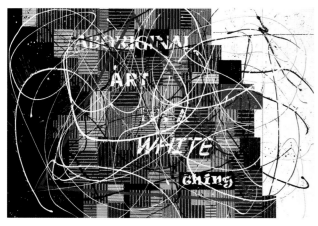

Richard Bell, *Scientia E Metaphysica (Bell's Theorem)*, 2003. Acrylic on canvas, 94 ½ × 212 ¾ in. Museum and Art Gallery of Northern Territory, Darwin. Courtesy the artist and Milani Gallery, Brisbane

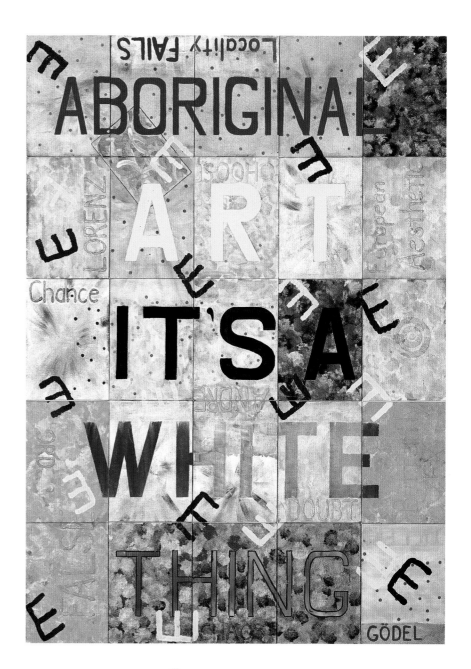

**Guilty**
2003
Acrylic on canvas
35 × 47 in.
Courtesy Milani Gallery, Brisbane

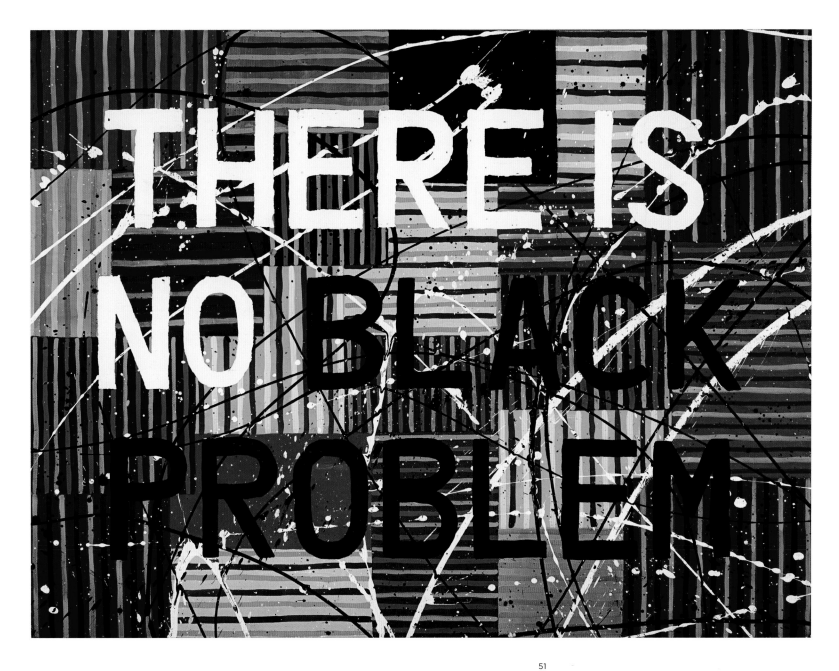

# 15

**The Cleaner**
2004
Acrylic on canvas
36 × 48 in.
Private collection, Brisbane

In 2004, during a period of low sales (which his dealer attributed to collectors being unable to "live with" his provocative paintings), Bell began his "Made Men" series. These works appropriate the Pop aesthetic of Roy Lichtenstein, whose "Interiors" series often incorporates work by other "masters" on walls as decoration. In *The Cleaner*, Bell quotes directly from a 1991 painting by Lichtenstein (see illustration), which depicts a bedroom decorated with art by Claude Monet. In Bell's quotation, he has placed miniaturized versions of three of his own paintings above beds and bureaus—in this instance (from left to right), *I Am Not Sorry, I Wanna Lick All Around Your Stretch Marks,* and *Oh Richie . . . I Love You Too But . . .* —in order to demonstrate how nicely his works can be displayed in bourgeois homes, signified by the presence of the blonde cleaner whose hair is visible at the right-hand edge of the painting.

Roy Lichtenstein, *Interior with Water Lilies*, 1991. Oil and acrylic on canvas, 126 ½ × 179 ½ in. Tate Collection; Presented by the Douglas S. Cramer Foundation in honor of Dorothy and Roy Lichtenstein, 1997

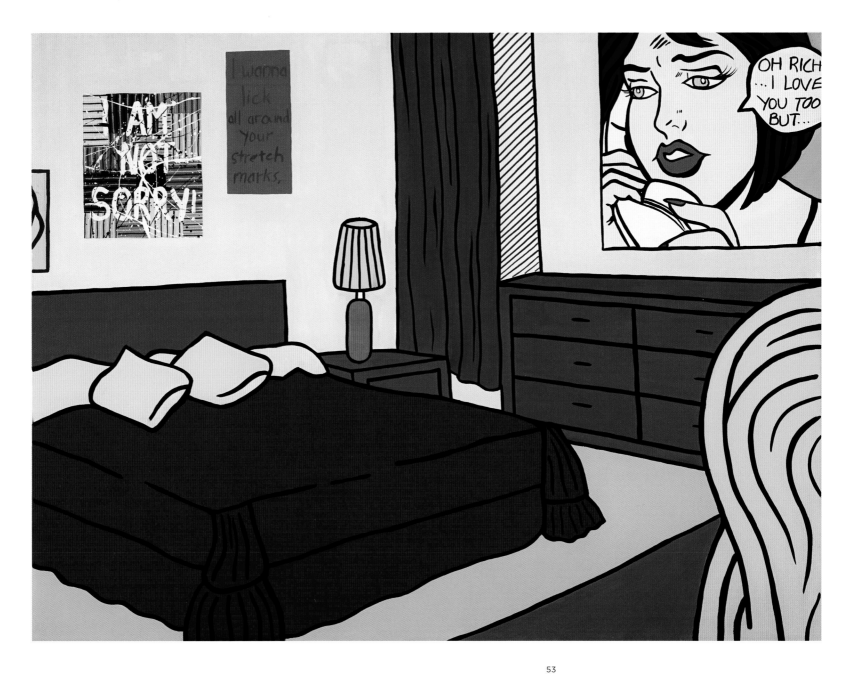

# 16

**Uz vs. Them**
2006
DVD projection with sound, 2 minutes 50 seconds
Courtesy the artist

Bell began making films in 2006 as a new means of communicating his larger political ideas. *Uz vs. Them*, his first film, is a parody of a promotional clip for a boxing match that pits a "Magnificent Black Hero" (Bell) against an "Angry White Dude." "Uz" versus "them," then, becomes "black" versus "white." While the black hero postures lazily in front of a mirror, voluptuous white girls massage his shoulders and shout, "We love you Richie." Meanwhile, the white dude trains vociferously with a sparring partner and spouts racist comments. He fears losing to a black man. Bell, on the other hand, wants to teach him "a history lesson," pontificating that "I don't need a tax cut. I want my whole country back." With sarcasm, Bell also states, "I'm not a racist; some of my best friends are white," and reverses racist stereotypes by exclaiming, "The trouble with white people is that they're lazy." Ultimately, the film takes on nationalist undertones as the two men from diverging racial backgrounds metaphorically fight each other for ownership of Australia.

17

**Wewereherefirst**
2007
Acrylic on canvas, 2 parts
96 × 144 in. overall
Private collection, Brisbane

Main text: *We were here first*
Text: *Pay me to be an abo, Why do you feel guilty,
There is no excuse for treating aboriginal people
badly, U have defied your upstanding citizens, You
have defied the united nations, You have defied
the laws of humanity, You have defied your god*

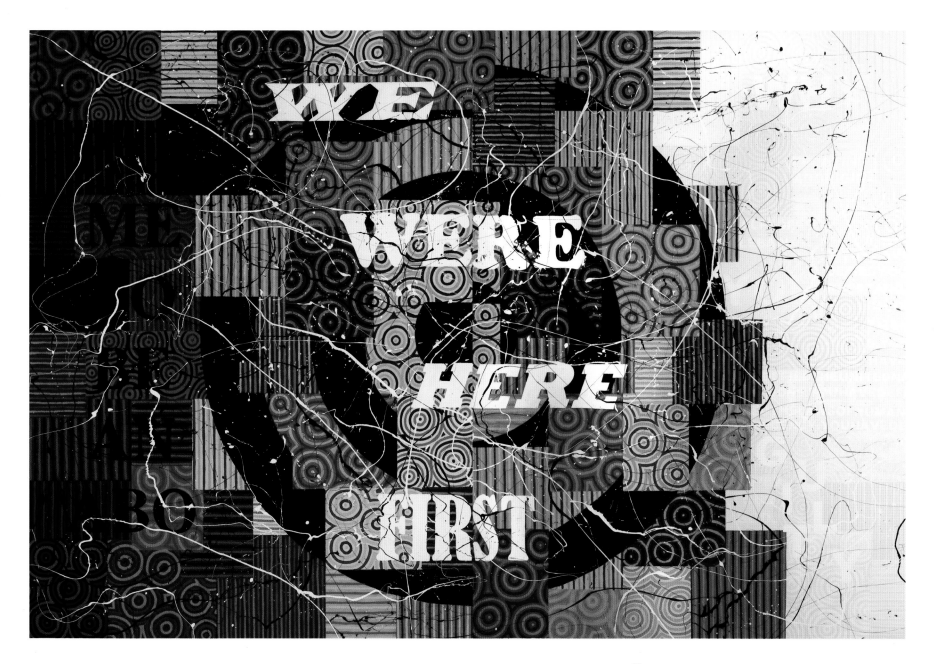

**The Peckin' Order**
2007
Acrylic on canvas
60 × 60 in.
Private collection, Brisbane

The title of this painting makes pointed reference to the hierarchical system of social organization that, in Australia, places all immigrants above Indigenous people. Hence the black woman's thought bubble that reads "Thank Christ I'm not Aboriginal!"

This painting is part of a series called "Made Men" in which the artist appropriates the Pop aesthetic of Roy Lichtenstein. Here Bell quotes directly from a 1965 color photolithograph (see illustration); however, he has inserted a thought bubble and changed the complexion of Lichtenstein's girl to non-white.

Roy Lichtenstein, *Shipboard Girl*, 1965. Color lithograph 26 ¼ × 19 ½ in. National Gallery of Australia, Canberra; Felix Man Collection, Special Government Grant 1972. © Estate of Roy Lichtenstein/ Licensed by Viscopy 2010

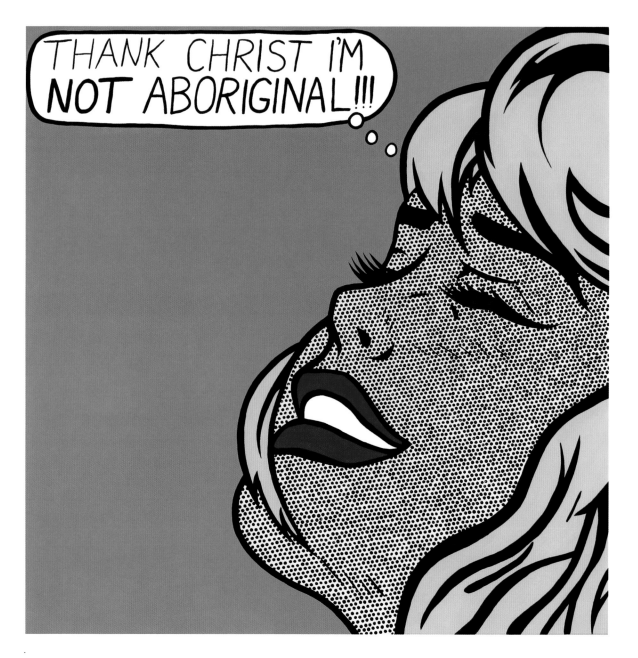

**Psalm Singing Suite**
2007–09
Installation of approximately 30 paintings, all acrylic on canvas
Dimensions variable
Courtesy Milani Gallery, Brisbane

Like a retrospective in miniature, *Psalm Singing Suite* consists of approximately thirty small-scale Lichtenstein-inspired Pop paintings that address issues related to Aboriginal politics. With text-works directing the viewer to "give it all back" and "kick somebody else," Bell demands land rights for Aborigines; in others that read "I am not a noble savage," he dismisses exoticizing ideas of "the primitive other"; in "white girls are easy" and "white people are lazy," he inverts the traditional racist stereotype for blacks. Lichtenstein's white hero, Brad, is transformed into a loud-mouthed, sarcastic black hero named Richie. Throughout the series, Bell also samples from Aboriginal painter Emily Kam Kngwarreye, Jackson Pollock, and central desert painting, as well as his own work, such as *The Peckin' Order* (cat. no. 18) and *I Like Art*, which he has produced in miniature.

The series title makes pointed reference to Mulrunji Doomadgee, who was murdered while in police custody on Palm Island in northern Queensland in 2004. To Bell, this event signified the long, unbroken line of oppression, perpetrated primarily by Christians who clearly do not adhere to the teachings of the biblical psalms.[1] As Hetti Perkins explains:

> *With its biblical references, the series chillingly evokes the climate of fear engendered by the frightening prevalence of institutionally sanctioned acts of violence against Aboriginal people. These works declaim the ungodly hypocrisy of a nation that professes Christian values yet will not allow the "meek" basic human rights, much less to inherit the earth.*[2]

Moreover, as can be seen in his catalogue essay here, "Psalm Singing" is Bell's term for the process of denying racism in Australia.

1. Richard Bell, personal conversation with the author, August 26, 2010.
2. Hetti Perkins in Richard Bell and Hetti Perkins, Brenda Croft (ed.), "Richard Bell," *Culture Warriors: National Indigenous Art Triennial*. Exhibition catalogue. Canberra, A.C.T.: National Gallery of Australia, 2007, p. 6.

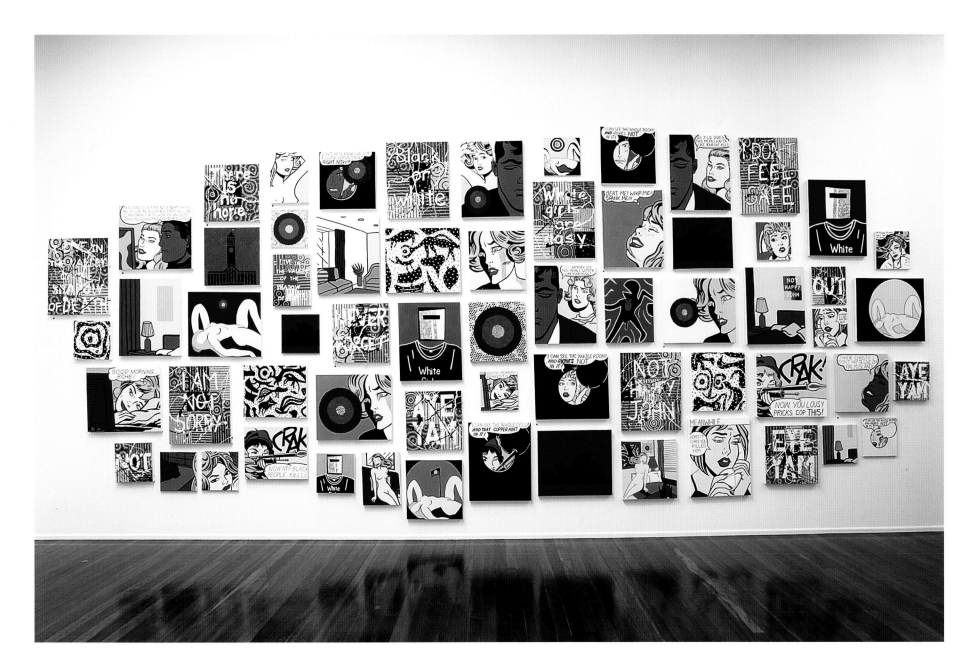

**Contra**
2008
Acrylic on canvas
71 × 94 in.
Collection Tom Lowenstein, Melbourne

Text: *Oldest culture in the world the longest*
*continually running civilization in human history,*
*You don't have culture you can call your own, What*
*our country imposes on you is all that you can*
*claim, Everything else is stolen, Give it all back*

63

**Scratch an Aussie #4**
2008
Digital print on aluminum
38 ½ × 25 ½ in.
Courtesy Milani Gallery, Brisbane

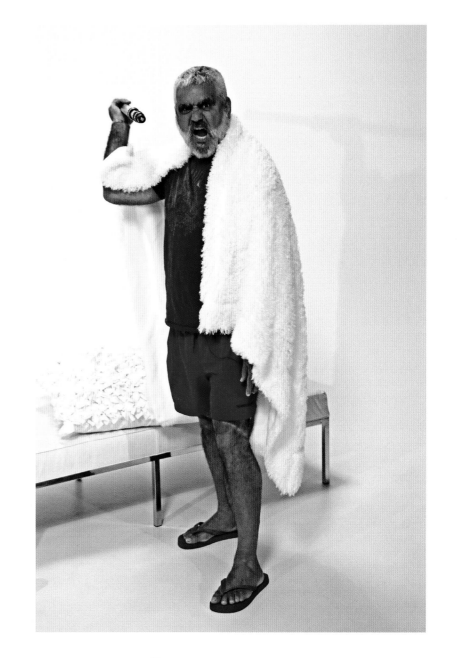

**Scratch an Aussie**
2008
DVD projection with sound, 10 minutes
Courtesy Milani Gallery, Brisbane

Bell's ability to shock with public actions and politically provocative artworks is perhaps best demonstrated in his video trilogy *Imagining Victory* (2008–12), which includes *Scratch an Aussie*, *Broken English* (cat. no. 23), and *The Dinner Party*. In these three videos, Bell layers complex issues utilizing a brilliant strategy of interwoven narratives, a back-and-forth play or battle between Indigenous and white Australians that emphasizes the country's glaringly contradictory race politics.

In *Scratch an Aussie*, Bell overturns political and social norms by masquerading as a black Sigmund Freud psychoanalyzing racist white Australians who recline on a sofa in gold lamé bikinis—like exoticized "others." They complain about the loss of personal property (iPods, house keys, and other everyday objects) and their feelings of victimization. Out of concern for his white patients, who "seem to have the weight of world on their shoulders," Bell seeks out therapy for himself and is analyzed by Black Power leader Gary Foley. These different sessions are interwoven throughout the video, juxtaposed with racist jokes about Aborigines and word associations that reveal the unconscious racism within Australian culture: if you *scratch an (white) Aussie*, racism is always just beneath the surface.

In *Broken English*, titled after the 1979 Marianne Faithfull rock album, Bell investigates Indigenous politics, asking why Australian Aborigines appear to lack a vision for their own future. His quest for answers takes him first to a re-enactment of the arrival of the British in Australia, this time rewritten to depict Aborigines as participants in their own subjugation. He roams the streets of Brisbane in search of answers, asking locals questions that result in varying and often disturbing responses: do Aborigines have a fair go in this country? Do you reckon that Australia was peacefully settled? What do you think about Aboriginal people? His continued search for answers brings him to a VIP fashion opening at Brisbane's Gallery of Modern Art, where he attempts to hobnob with the rich and famous and challenge them about Indigenous politics, with dismal results. As counterpoint to this glitz and glamour, Bell also visits the remote Indigenous community of Cherbourg, interviewing the residents, all of whom state that land rights, acceptance, justice, and tradition are of the highest priority when asked the question "What do we [Aborigines] want?" All of these scenarios are interwoven within the video with the Black Power diatribe of Gary Foley and Bell as they play chess for the ultimate prize: an empowered future.

*The Dinner Party*, still in progress, will complete the trilogy. In this final video, the artist psychoanalyzes Australia's "Chardonnay socialists" during a dinner party in an opulent home overlooking Sydney Harbor. As with the previous two videos, parallel narratives are interwoven: Bell's close friends discuss the same subject over backyard barbecues while Bell and Foley truck a statue of Captain Cook from Queensland to Sydney to toss it, symbolically, into Botany Bay.

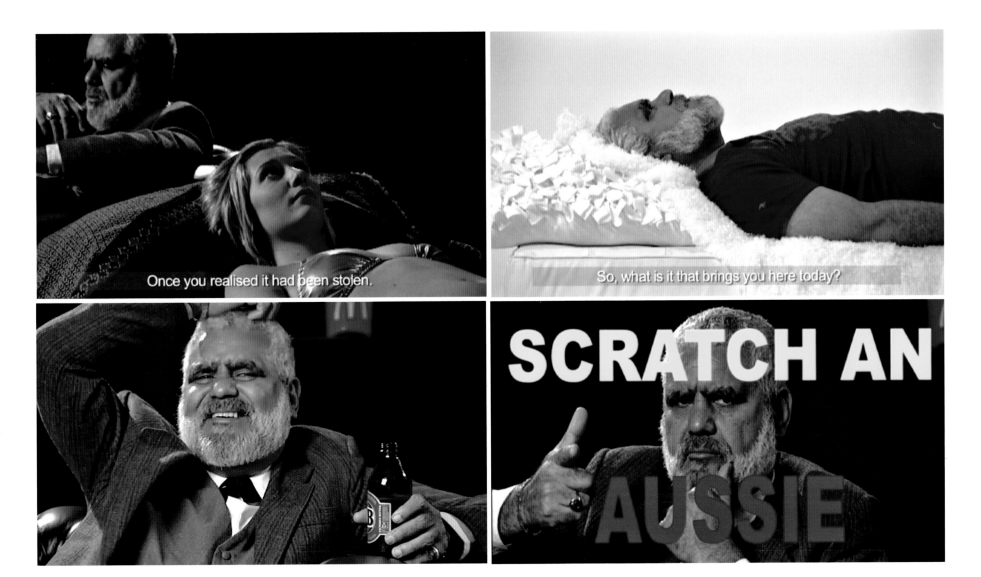

23

**Broken English**
2009
DVD projection with sound, 10 minutes
Courtesy Milani Gallery, Brisbane

**I Am Not Sorry**
2009
Acrylic on canvas
60 × 47 in.
Kurilpa Collection, Brisbane

Between the 1860s and the 1970s, approximately fifty thousand Aboriginal and Torres Strait Islander children were forcibly taken from their families as part of the government policies of the day.[1] These children were placed in group homes or made to work as domestic servants; many were sexually, physically, and mentally abused. For decades, the Indigenous population who were members of the "Stolen Generations" had been asking for a government apology.

In 2001, Bell began a series of "I am not sorry" text paintings that took the federal government to task for refusing to apologize for *all* past injustices. The first in the series, *Little Johnny* (2001), was made in direct response to then-Prime Minister John Howard's refusal to participate in the Walk for Reconciliation over Sydney Harbor Bridge.

In February 2008, Australia's newly elected prime minister, Kevin Rudd, offered a formal apology to the Indigenous population. The painting featured here—decorated with "authentic" stencilled handprints and boomerangs—is Bell's response to Rudd. As the artist explains, "When Rudd made the apology, he was referring only to the Stolen Generations. The "sorry" didn't address issues associated with dispossession and colonization."[2]

1. The number of individuals victimized by these governmental policies cannot be accurately analyzed, principally because of the lengthy time frame and faulty records. The figure of fifty thousand is frequently noted; however, many believe the figures could be four times that.
2. Richard Bell, personal correspondence with the author, May 2010.

**GFC (Global Financial Crisis)**
2010
Acrylic on canvas
96 × 144 in.
Courtesy Milani Gallery, Brisbane

Text: *Four words one number 8, Freddie, Mac,*
*Liquid, Ty, Fannie, Mae, Credit, Solvency, Stock,*
*Market, Bank, ING, Regulation, Credit, Bally,*
*Agencies, Mortgage, Ted, AG, Fiscal, Stim, That,*
*Monitary, Policy housing bubble, Stable rate,*
*Mortgage, Mortgage backed, Est, Ment, Banks,*
*Hed, Shadow, Bank, Stemsecom, Mortgage, Secur,*
*Rent, Account, Deficit, Savin, Gglut, Treasury Bond*

26

**Blackfella's Guide to New York**
2010
DVD projection with sound, duration not yet determined
Courtesy Milani Gallery, Brisbane

Bell created this video for his fellow Aborigines while
on an artist's residency in New York in 2009–10. The
term "blackfellas" is used by Indigenous people,
both men and women, to refer to themselves.

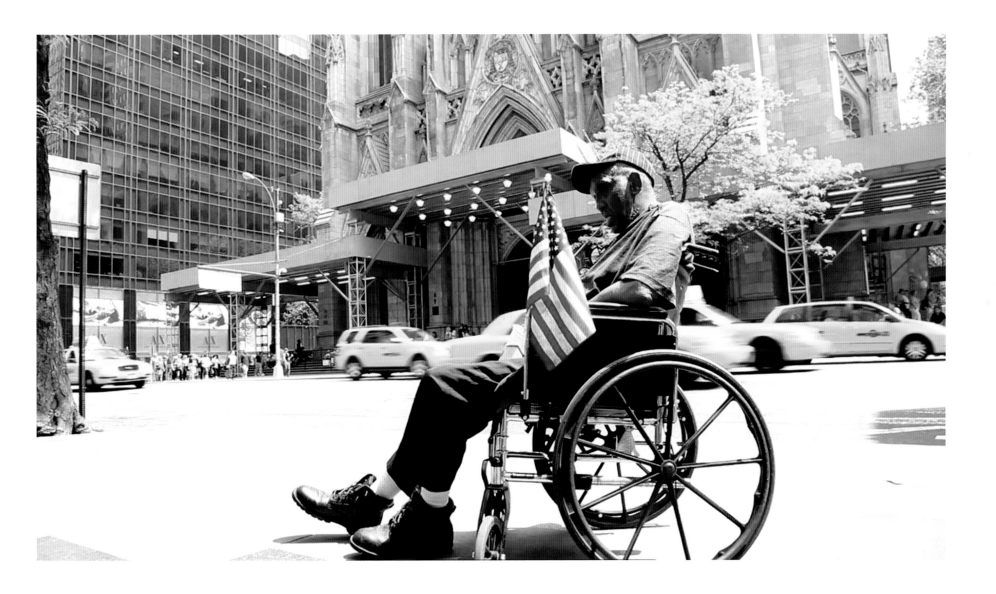

# TIMELINE

Richard Bell and Recent Significant Events in Aboriginal and Torres Strait Islander Activism

Compiled by Amy Spencer

**Contemporary Politics/History**

**Richard Bell**

| | |
|---|---|
| **1953** | Richard Bell is born in Charleville, a town in south western Queensland. He belongs to the Jiman, Kooman, Kamilaroi, and Goreng Goreng Indigenous peoples. |
| **1957** | The Victorian Aborigines Advancement League is founded. |
| **1958** | The Federal Council for the Advancement of Aborigines and Torres Straits Islands is established. |
| **1959** | Bell and his brother Marshall go with their mother to live at the Retta Dixon Home in Darwin, Northern Territory, where she is employed. |
| **1962** | The Commonwealth Electoral Act is amended to give all Aboriginal and Torres Strait Islander[1] people the right to vote in Commonwealth elections. |
| **1963** | Yolngu leaders submit land rights petitions mounted on bark to the Commonwealth Government. |
| **1965** | Arrernte student Charles Perkins leads a "Freedom Ride" bus tour with the University of Sydney's Student Action for Aborigines group. |
| | Bell and his family leave the Retta Dixon home and return to Queensland. |
| **1966** | Around 200 Gurindji people, led by spokesman Vincent Lingiari, begin a seven-year strike over poor living conditions and low wages at Wave Hill cattle station. |
| **1967** | As a result of a referendum, the Commonwealth Government is given constitutional power to legislate on Aboriginal affairs and include Aboriginal people in the census. |
| **1970** | Aboriginal people organize a protest at La Perouse Aboriginal Reserve at Botany Bay on the bicentenary of Captain Cook's exploration of Australia. |
| | Bell's mother dies, and he moves to Dalby (300 miles east of Charleville). |
| **1971** | The Aboriginal flag is designed by Luritja/Wombai artist Harold Thomas. |
| | The Gove land rights case, Milirrpum vs. Nabalco, is lost by the Yolngu people of Yirrkala. |
| **1972** | The "Aboriginal Embassy"—a red tent with a blue beach umbrella—is erected outside Parliament in Canberra by Redfern-based Aboriginal activists. |
| **1973** | The Aboriginal Land Rights Commission is established. |
| **1974** | Bell leaves Queensland to become involved in the Aboriginal civil rights movement. During the next decade, he gets to know political activists, artists, poets, and writers in Sydney, Moree (New South Wales), and Melbourne. |
| **1975** | A portion of land is returned to the Gurindji people. At the hand-back ceremony, Prime Minister Gough symbolically pours soil into the hand of Lingiari. |
| **1976** | The Aboriginal Land Rights (Northern Territory) Act is passed in parliament. |
| **1978** | Yolngu people receive title to their land under the Land Rights Act. |
| **1982** | During the Commonwealth Games, around 500 Aboriginal people occupy Musgrave Park in Brisbane to protest the racist Queensland Government. |
| | Bell attends Commonwealth Games protest in Brisbane. Lives in Sydney and works for the New South Wales Aboriginal Legal Service. |
| **1985** | The Commonwealth Government announces its Preferred National Land Rights Model. In response, more than 1,000 Aboriginal people march on Parliament House in Canberra. The Queensland Government passes the Queensland Coast Islands Declaratory Act, which is intended to abolish any native title rights, retrospectively. |
| | Uluru (Ayer's Rock) is returned to its traditional owners, the Pitjantjatjara people. |
| **1986** | Twenty years after the Gurindji walk-off, the Commonwealth Government gives them inalienable freehold title to their land. |
| **1988** | Prime Minister Hawke is presented with the Barunga Statement, a declaration of Aboriginal political objectives calling for a treaty to further Aboriginal rights. |
| | On January 26, during Australia Day celebrations in Sydney, around 20,000 Aboriginal people and their supporters rally for the "March for Freedom, Justice, and Hope." |
| | Bell participates in the Australia Day/Invasion Day protest. With brother Marshall and Liz Duncan, runs Aboriginal art gallery, Wiumulli, in South Brisbane. |
| | Bell begins producing his own artwork as a natural progression of political activism and interest in art. |
| **1989** | Bell has first solo exhibition of predominately small, mixed-media works with collage. |

1. Hereafter, the term "Aboriginal" will be used to refer to Australia's Aboriginal and Torres Strait Islander peoples.

| 1990 | The Aboriginal and Torres Strait Islanders Commission (A.T.S.I.C.) is established by the Commonwealth Government. |
| | Bell participates in the exhibition *Balance* at the Queensland Art Gallery. |
| | The Campfire Group is formed by Michael Eather and Marshall Bell with Richard Bell's involvement. |
| 1991 | Bell participates in some of the first Campfire Group exhibitions held in the dressing shed at Spring Hill Baths. |
| | The National Gallery of Australia purchases Bell's *Crisis: What To Do about This Black and White Thing* (1991). |
| 1992 | The High Court hands down its decision in the case of Eddie Mabo and Others vs. the State of Queensland, recognizing that the Meriam people have the right to native title of the islands of Mer, Dauar, and Waier in the Torres Strait. |
| | Prime Minister Keating delivers his Redfern address, which calls for reconciliation to be part of the national agenda. |
| | Bell helps organize and attends the first Queensland Indigenous Artists' Conference at Yarrabah community. |
| | Participates in the 9th Sydney Biennale with the Campfire Group. |
| 1993 | The Native Title Act is passed by Federal Parliament, recognizing native title and providing a process by which native title rights can be established. |
| | Participates in *Australian Perspecta: A Biennial Survey of Australian Art* at the Art Gallery of New South Wales. |
| | Wins the National Aboriginal Art Award at the Gold Coast Arts Centre. |
| 1994 | Bell participates in the group exhibition *True Colours Aboriginal and Torres Strait Islanders Raise the Flag* in England. |
| 1994– 2001 | Bell takes a hiatus from producing art to spend more time with his children. |
| 1996 | The High Court of Australia hands down the Wik decision, confirming that pastoral leases do not necessarily override claims to native title. |
| 1997 | The Bringing Them Home Report uncovers in stark detail the suffering of the "Stolen Generations"—Aboriginal children forcibly separated from their families under government policy. |

| 2000 | More than 250,000 people participate in the Corroboree 2000 Bridge Walk across Sydney Harbor Bridge in support of Aboriginal Australians. |
| 2001 | Bell moves to Brisbane and returns to making art full-time. |
| | Participates in *Dreamtime: The Dark and the Light* in Klosterneuburg, Austria. |
| 2003 | Wins the 20th Telstra National Aboriginal and Torres Strait Islander Art Award. |
| 2004 | Shortlisted for the Archibald Portrait Prize at the Art Gallery of New South Wales. |
| | Forms proppaNow, a collective of Queenslander Aboriginal artists. |
| 2005 | A.T.S.I.C. is abolished. |
| 2007 | The Little Children Are Sacred Report is released by a Board of Inquiry into the protection of Aboriginal children from sexual abuse. In response, the Northern Territory Emergency Response Act (also referred to as "the intervention") is passed. |
| 2008 | Ten years after the Bringing Them Home Report is released, newly elected Prime Minister Rudd apologizes to the Stolen Generations. |
| 2009–10 | Lives in New York as an International Fellow at Location One. |
| 2009 | Has first U.S. exhibition—*Richard Bell: I Am Not Sorry* (Location One, New York), curated by Maura Reilly. |
| 2010 | The Commonwealth Government forms the National Congress of Australia's First Peoples. |
| 2011 | The exhibition *Richard Bell: Uz vs. Them*, organized by the AFA, commences touring throughout the U.S. |

From **Psalm Singing Suite**
2007–09 (cat. no. 19)

**Key Sources**
Foley, Gary. *The Koori History Project.*
http://www.kooriweb.org/ (accessed June 2010).

Lowish, Susan, and Elina Spilia. "Chronology." In Judith Ryan, *Land Marks.*
Exhibition catalogue. Melbourne: National Gallery of Victoria, 2006.

# BIBLIOGRAPHY

## Books, Exhibition Catalogues, Brochures, Essays, Interviews, and Videos

Bell, Richard, and Anne Baker. "Artist's T-shirt Sparks Controversy." *Australian Broadcasting Corporation Transcripts*. August 20, 2003 (accessed June 2010, via Factivia).

Bell, Richard, and Hetti Perkins. "Richard Bell." In *Culture Warriors: National Indigenous Art Triennial*, edited by Brenda Croft, 59–63. Exhibition catalogue. Canberra, A.C.T.: National Gallery of Australia, 2007.

Butler, Rex, and Morgan Thomas. "I Am Not Sorry: Richard Bell Out of Context." *Gary Foley's Koori History Website*. May 2003. http://www.kooriweb.org/bell/article1.html (accessed June 2010).

Chambers, Edward, ed., INIVA, and Boomalli Aboriginal Artists Co-operative. *True Colours: Aboriginal and Torres Strait Islander Artists Raise the Flag*. Exhibition catalogue. Chippendale, New South Wales: Boomalli Aboriginal Artists Co-operative, 1994.

Croft, Brenda L. "Cultural Con/Texts: Apologists vs. Apologies." In *Art Museums: Sites of Communications*. Canberra: National Gallery of Australia, March 14–15, 2003.

Eather, Michael, ed. *Shoosh! A History of the Campfire Group*. Exhibition catalogue. Brisbane: Institute of Modern Art, 2005.

"Half Light: Portraits from Black Australia." Video. (2008). Prod. Art Gallery of New South Wales. http://www.youtube.com/watch?v=QcTo3ugfc0k&feature=related (accessed June 2010).

Helmrich, Michele. "Richard Bell: Celebration/Unforgiving." In *UQ Art Museum New: Selected Recent Acquisitions 2007–2008*, 128. Brisbane: University of Queensland Art Museum, 2008.

"Interview with Richard Bell by Rachael Maza." *Message Stick*. Television. Prod. Rima Tamou. ABC1. Nationwide, 6 p.m., April 30, 2004.

Leonard, Robert, ed. *Richard Bell: Positivity*. Exhibition catalogue. Brisbane: Institute of Modern Art, 2007.

*Marella: The Hidden Mission*. Emu Plains, New South Wales: Penrith Regional Gallery & The Lewers Bequest, 2009.

Morrell, Timothy. *Richard Bell: Scratch an Aussie*. Exhibition brochure. Adelaide: Contemporary Art Centre of South Australia, 2009.

Quaill, Avril. "There Goes the Neighbourhood: The Works of Vernon Ah Kee and Richard Bell." In *Brought to Light II: Contemporary Australian Art 1966–2006 from the Queensland Art Gallery Collection* edited by Lynne Seear and Julie Ewington, 341–47. Brisbane: Queensland Art Gallery Publishing, 2007.

*Richard Bell, Black Activist, 1982, Brisbane, Stolenwealth Games*. Video. (1982). http://www.youtube.com/watch?v=rNYYD525G5w (accessed June 1, 2010).

Thomas, Morgan. "Who's Dreaming Now?" *Made Men*. Exhibition brochure. Brisbane: Metro Arts, 2003.

## Periodicals

Aldred, Debra. "Outside the Square." *The Courier Mail*, September 20, 2003.

Alexander, George. "Text Appeal: Australasian Text in Images." *ArtAsiaPacific* 58 (2008): 131–35.

Bagnall, Diana. "Black Belting." *The Bulletin*, August 20, 2003.

Bell, Richard. "We're Not Allowed to Own Anything." *Art and Australia* 46, no. 2 (2008): 228–29.

Butler, Rex. "Richard Bell's Psychoanalysis." *Australian Art Collector* 50 (2007): 137–43.

Pym, William. "Richard Bell: Mockery Gives Way to Magic." *ArtAsiaPacific* 69 (2010): 82–87.

Thomas, Nicholas. "Art Against Primitivism: Richard Bell's Post-Aryanism." *Anthropology Today* 11, no. 5 (1995): 15–17.

Webb, Penny. "Black View of White Stuff." *The Age*, September 20, 2004.

# INDEX

Pages numbers in *italics* indicate illustrations